THE HAMLYN
BASIC GUIDE TO
PHOTOGRAPHY

HAMLYN

Editor: Frances Jones
Consultant Editor: John Farndon
Art Editor: Caroline Dewing

Published by
The Hamlyn Publishing Group Limited
Bridge House, 69 London Road
Twickenham, Middlesex TWI 3SB, England

Produced by Marshall Cavendish Books Limited
58 Old Compton Street
London W1V 5PA

© Marshall Cavendish Limited 1986
Second impression 1987

This material was first published
by Marshall Cavendish in
the partwork PHOTO

ISBN 0 600 373142

Printed and bound in Spain
by Cronion S.A., Barcelona

INTRODUCTION

For the beginner who wants to progress from snapshots to serious photography, there is really only one camera—the single lens reflex or SLR. However, there is a world of difference between taking snapshots and high-quality photographs and *The Hamlyn Basic Guide to Photography* helps the beginner to bridge that gap.

The book introduces you to the basic workings of the SLR and gives useful advice on what to look for when buying your first camera, as well as how to best go about building an integrated system. The book then teaches all the basic techniques from exposure and focusing to the use of interchangeable lenses. Filters can be a source of mystery, so there is a comprehensive guide to the filters available and when to use them. And there is a section on special effects you can use to impress your friends with your newly acquired skills.

The Hamlyn Basic Guide to Photography is packed with practical ideas and techniques, explained in easy-to-follow terms. Beautiful photographs taken by the professionals are there to inspire you, and simple charts and artworks are included to help you. So, whether your camera is a budget SLR or a top-of-the-range model, this book will develop your talent for taking genuinely creative photographs.

CONTENTS

The 35mm SLR

SLRs have developed considerably over the years and some modern SLRs are very sophisticated pieces of equipment. But the basic layout has remained the same. So, whether your camera is a simple budget SLR or a refined top-of-the-range model, you should find all the principle controls fall easily to hand.

Film movement. The film always runs from a cassette on the left across the back of the camera to a take-up spool on the right. Wind on between pictures with the lever top right of the camera. Rewind the exposed film by pressing the release button on the base of the camera and turning the rewind lever (or knob).

Exposure. On manual cameras, for correctly exposed pictures, you must set the shutter speed dial on the top of the camera and the aperture control (the back ring on the lens). On automatic cameras this is done automatically. Take the picture by pressing the shutter release button.

Focusing. To ensure sharp pictures, you must adjust the focusing control on the ring around the lens.

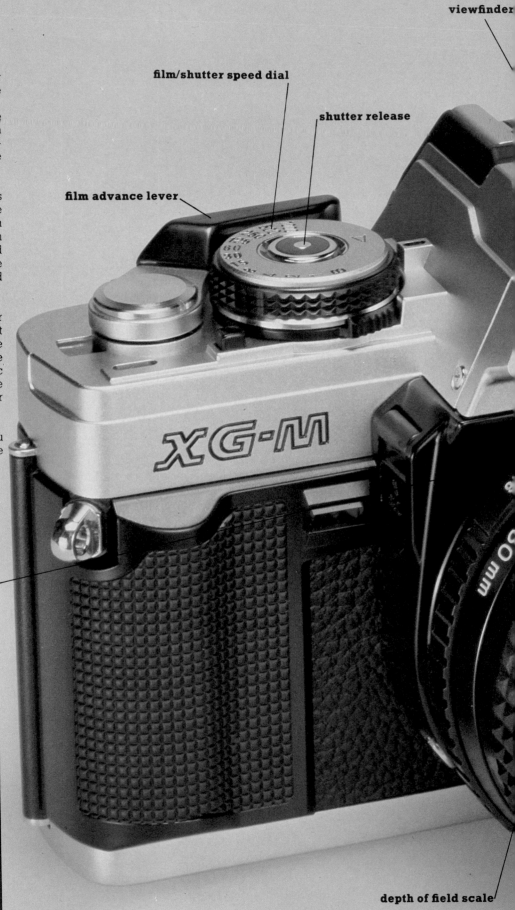

viewfinder

film/shutter speed dial

shutter release

film advance lever

aperture ring

depth of field scale

Taking a picture
1. Frame your subject in the viewfinder.
2. Turn the focusing ring until the picture appears sharp.
3. Set the exposure controls
 Manual: set the shutter speed desired and turn the aperture ring until viewfinder signal indicates correct. exposure setting
 Semi-auto: set desired shutter speed (shutter priority models) or aperture (aperture priority models).
 Automatic: no action needed.
4. Check framing and focusing.
5. Brace camera firmly.
6. Press shutter release.
7. Wind on film advance lever.

Viewing *Before the shutter is released the lens diaphragm is at full aperture to aid focusing*

Button pressed *The mirror rises and the diaphragm closes to working aperture within 6 milliseconds*

Shutter open *When the shutter is fully open, the flash contacts are closed to trigger the flash*

Shutter closes *As soon as the set time has elapsed, the shutter snaps shut, covering the film*

Mirror falls *Finally the mirror falls, and the aperture opens up again for viewing*

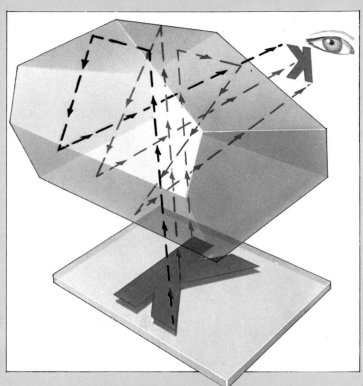

Pentaprism *Three reflections reverse the image on the focusing screen*

grapher looks through the viewfinder, the image is seen the right way round, and not inverted. The image on the film is both inverted and reversed, which makes composition difficult. The prism corrects this.

The eyepiece of most SLRs is adjusted for people of normal eyesight. Short- and longsighted photographers need corrective eyepieces if they are to use the camera without their spectacles.

The lens
All 35 mm SLRs accept interchangeable lenses, which are usually fixed to the camera body by some kind of bayonet fitting. Focusing the lens is carried out by a screw thread which runs round the inside of the lens tube. This is called a *helicoid*. When the lens barrel is turned, the lens moves closer or further away from the film, and distant or nearby objects are thus made sharp.

All the lenses contain an *iris diaphragm* of inter-leaving blades for varying the aperture. On most SLRs this is kept at full aperture for focusing and composing, and is stopped down at the moment of exposure to the working aperture, which is

SLR sequence *At 1/30 sec shutter speed, the sequence takes 3/4 sec to complete*

set by a control ring on the lens. This means that the image on the focusing screen is bright and easy to see through the viewfinder, but is the correct brightness when it reaches the film.

Exposure meter
Most SLRs have some sort of an exposure meter, which usually reads through the lens (often abbreviated to TTL). This measures the light falling on the focusing screen, and on an automatic camera adjusts the aperture or the shutter speed to give the correct exposure.

On manual models, the meter causes a display in the viewfinder to indicate the correct exposure. The photographer then has to set the camera controls to give the right exposure.

Besides the exposure meter readout, which often takes the form of light emitting diodes—LEDs—or a meter needle, many cameras display either the shutter speed set, or the aperture in use, sometimes both.

The shutter
Virtually every 35 mm SLR has a *focal plane shutter* in the body of the camera rather than a *leaf shutter* in the lens which makes it easier to use interchangeable lenses. The shutter, the aperture and the mirror all work together in a precise sequence, repeated each time a picture is taken. This is controlled by gears and cams in the camera body.

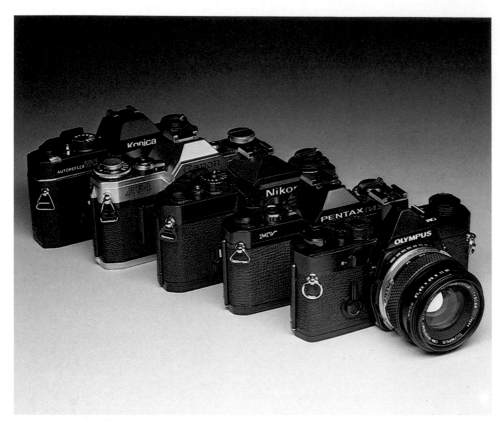

When you decide to buy your first SLR, you will find a wide range of cameras to choose from. Fortunately, standards are remarkably high and very few SLRs are poor value for money—price is nearly always a genuine reflection of quality and specifications. So, essentially, you are free to choose the camera that suits your needs (and pocket) best.

The most important decision you must make is usually about the type of exposure system you want—whether you want it fully automatic, partly automatic or manual. Only once you have decided this can you start to make detailed comparisons of handling characteristics and extra features in individual makes.

Traditional methods of exposure
Before the introduction of automatic exposure control and through the lens light meters, photographers used separate, hand-held light meters to determine the correct exposure. They first took a reading on the hand-held meter of the light falling on the subject and, by using scales on the meter, they decided which combination of shutter speed and aperture would give the correct exposure. They would then transfer these settings on to the camera and lens. This method of exposure setting is still followed on modern cameras that do not have built in meters.

Camera choice *The range of cameras that are available is very large. The most important differences between them is in the way the meters work*

Whenever a photograph is taken, all these operations have to be performed, regardless of whether an automatic camera or a manual camera is being used. The difference is that, the more automatic the camera, the more functions it takes over from the photographer.

Aperture and shutter priority
Most of the SLRs that are now available offer some type of exposure automation, and these can be divided into two types: aperture priority automatics and shutter speed priority automatics (though some of the more expensive cameras can be operated both ways).

On a shutter priority camera, the photographer sets the shutter speed that is required and the camera takes a light meter reading and adjusts the aperture to give the correct exposure to the film. A typical shutter priority camera is the Canon AE1. On this camera, the user first sets the shutter speed on a dial on the top plate of the camera, and gently presses the shutter release. By looking through the viewfinder it is possible to see an aperture scale on the right hand side of the focusing screen, over which a needle swings. This scale indicates the aperture which will be set by the camera. The light pressure on the shutter release switches on the camera's exposure meter, which presets the aperture, and moves the meter needle.

Aperture priority-Nikon FE

1 Meter on *The exposure meter is switched on. The switch for the meter on the Nikon FE is in the film wind lever, which is pulled out to switch it on*

2 Set aperture *On aperture priority cameras, the aperture ring on the lens is then set to the f-number that the photographer has chosen*

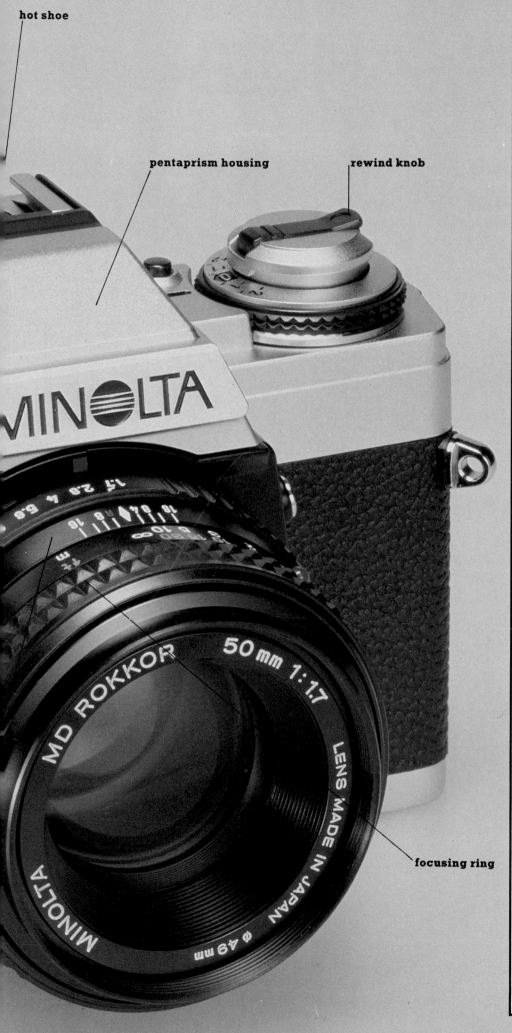

hot shoe

pentaprism housing

rewind knob

MINOLTA

MD ROKKOR 50 mm 1:1.7

MINOLTA LENS MADE IN JAPAN ⌀ 49 mm

focusing ring

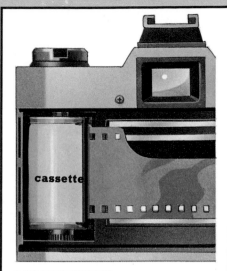

cassette

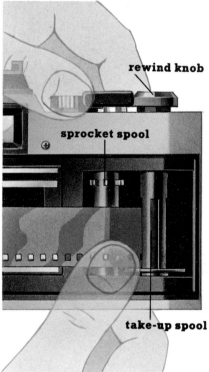

rewind knob

sprocket spool

take-up spool

Loading the camera

1. Set the film speed on the shutter speed dial.
2. Pull the rewind knob to open the camera back.
3. Slot in the film cassette as shown.
4. Push home rewind knob and turn until engaged in film spool.
5. Pull out film leader about 8cm.
6. Engage film on sprocket spool and slot the leader into the film take-up spool.
7. Turn the film advance lever slowly as far as it will go, keeping the film taut and checking that the spool is taking up the film properly. (If the film advance lever will not move, try pressing the shutter release first.)
8. Close the camera back.
9. Press the shutter release and wind on again. If the rewind knob turns as you wind on, the film is correctly loaded.
10. Press the shutter and wind on until the first frame appears in the film counter.

Chapter 1
THE CAMERA
What is an SLR?

Modern SLRs are generally very easy to use once you know the basics, and many photographers get by without ever knowing any more. But to make the most of SLR photography, you need to know how they work.

The term SLR stands for *single lens reflex*, which describes the system of lenses and mirrors in the camera that makes focusing and viewing simple: *reflex*, because the light from the lens bounces off a mirror before reaching the photographer's eye, and *single lens*, because there is only one lens which serves both for viewing and for taking the picture.

The reflex system is simple and usually very reliable. It has three main elements: a hinged mirror, a matt focusing screen, and a five-sided glass prism called a *pentaprism*. The mirror normally rests at an angle of 45° below the focusing screen, behind the lens, and projects the image formed by the lens upwards on to the screen. The pentaprism reflects this

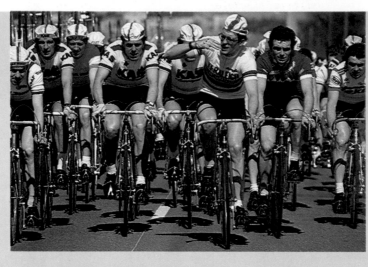

image so that it can be seen through the eyepiece—in effect, a simple magnifying glass—at the back of the camera, behind the prism.

The mirror and screen

The reflex mirror is a thin sheet of glass, coated on the front with aluminium—coating on the back would result in double images. It is hinged at the top. When the shutter release is pressed, it swings up out of the way, so that

Cycle race *SLRs are essential for accurate composition with long telephoto lenses*

light can reach the film. It also seals off the viewfinder so that light entering the eyepiece cannot reach the film. After the exposure, the mirror swings back down again, so that the image is once more visible in the viewfinder. For most exposures, the image vanishes for a very short period, less than

the blink of an eye.

The focusing screen is generally made of plastic (despite the fact that it is usually called 'matt glass', or 'ground glass') and the image formed on the lens, which is reflected by the mirror, is seen on this screen. Since the film and screen are the same distance from the lens, the image formed on each is the same. When one is in focus, the other one will also be sharp. Turning the lens barrel brings the image into focus, so the photographer can see the effect on the screen. This is probably the greatest advantage of the SLR: what you see on the screen is precisely what you get on the negative or slide.

The screen has a number of aids to focusing. These are called *microprisms* and *split image rangefinders*, and are described in detail in the box on page 25. They make it easier to see the exact point of sharp focus, though in normal light this should not be difficult.

If an ordinary matt screen were used, it would be bright in the centre, and dark at the corners. To avoid this, all SLRs have a type of lens below the screen to gather the light, making the image appear equally bright all over. This is a *fresnel lens*— it is thin and flat, and not convex like a normal lens.

The focusing screen in most cameras shows only a certain amount of the image— usually about 90 per cent. The cut off at the edges of the frame gives a small margin for error in the composition of the photograph.

The prism and eyepiece

The pentaprism reflects the image of the screen three times before it reaches the eyepiece. These reflections ensure that, when the photo-

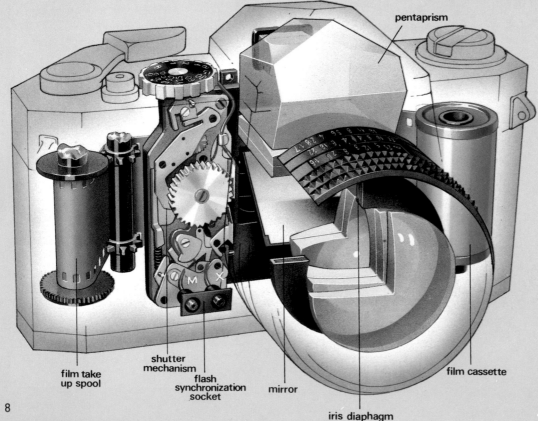

pentaprism

film take up spool

shutter mechanism

flash synchronization socket

mirror

iris diaphagm

film cassette

Camera construction *Most 35 mm SLRs have the same general arrangement*

Foreground flowers *Aperture priority automatics work well when depth of field is important. A small aperture was chosen here to keep everything in focus*

When the shutter release is pressed right down, the aperture is closed down to the value chosen by the camera, and the shutter fires.

Because this type of camera allows the user to set the shutter speed that is needed, it tends to find favour with camera users for whom the shutter speed is the most important factor. Sports photographers, for example, need to know exactly what shutter speed is set on the camera at the time of exposure, because it is usually important that the subject of the picture will be 'frozen' in motion rather than blurred. The user of a shutter priority automatic gives up control of the aperture that is used, but for many purposes control over the aperture is less important than selection of the best shutter speed.

With aperture priority automatics, the situation is reversed. Instead of setting the shutter speed, the user picks the aperture, and the camera selects an appropriate shutter speed. The Nikon FE is a camera of this type. The sequence of operations for this camera begins with the user setting an aperture on the scale around the lens. The choice of aperture would usually be dictated by the depth of field required in the photograph (see page 20). Having set the aperture, the photographer looks through the viewfinder and pulls the lever wind backwards. This switches on the meter and moves a small needle in

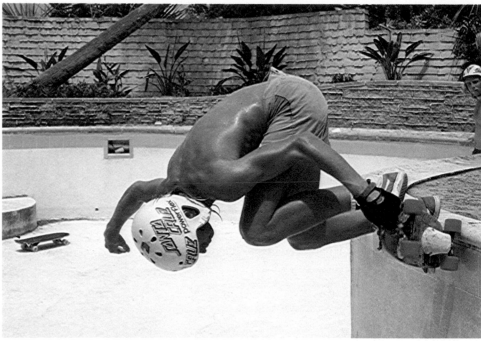

Speedy skateboard *If the subject of the picture must be frozen in motion, a shutter priority automatic will be easiest to use*

3 Viewfinder *Looking through the viewfinder, a scale is visible on the left hand side of the focusing screen, on which shutter speeds are marked. A needle swings over the scale, and comes to rest at the shutter speed that will be set by the camera's automatic meter*

4 Releasing shutter *At the moment of exposure, the aperture closes to the f-number chosen by the photographer, and the shutter speed is set by the camera to give the correct exposure*

Manual metering-Olympus OM1

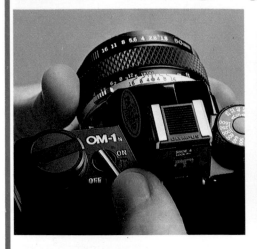

1 Meter on *The Olympus OM1 has a separate meter switch. This must be operated before a light meter reading can be taken with the camera*

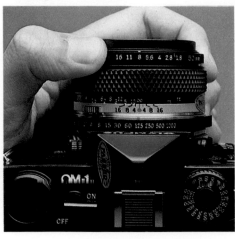

2 Set aperture *In this instance, the photographer first sets the aperture to a value that will give sufficient depth of field for the subject*

3 Viewfinder *A needle on the left hand side of the focusing screen moves over a pair of marks. Exposure is correct when it is centred*

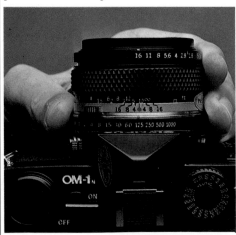

4 Shutter speed *In this case, the photographer adjusts the shutter speed to balance the meter needle. The shutter speed dial is around the lens mount*

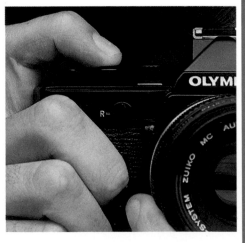

5 Release shutter *After focusing and composing the picture, the shutter release is pressed. Both aperture and shutter have been manually set*

the viewfinder to indicate the speed at which the shutter is going to operate. When pressure is applied to the shutter button the shutter will be released at the speed indicated in the viewfinder.

This system of operation is no better or worse than the shutter priority method, but is suited to a different type of photography, in which the aperture is considered by the photographer to be more important than the shutter speed. If a portrait is the subject of the picture, for example, the photographer must be sure that the whole of the model's face is in focus, so the aperture that is set is of great importance. Since the subject is unlikely to move very much, the shutter speed is less crucial.

Aperture priority automation is favoured by a lot of camera manufacturers, because the system requires fewer connections between the camera lens and body. To build a shutter priority automatic, on the other hand, some kind of mechanical linkage is needed between body and lens, to ensure that the correct aperture is set at the moment of exposure.

Manual cameras

Although shutter priority and aperture priority automatic cameras are the most common types, some other cameras fit into neither of these two categories. These are fully automatic cameras, and those which set the exposure without any intervention by the photographer—so-called 'programmed' cameras.

Manual cameras, such as the Olympus OM-1, have a meter needle visible through the viewfinder, but leave the photographer to do the work of changing the shutter speed and the aperture. To set the correct exposure on the OM-1, for example, the photographer first switches on the meter—on some manual cameras this is incorporated into the shutter release—and sets either the aperture or the shutter speed to the chosen value. Looking through the viewfinder, a meter needle is visible, and a pair of pincer-like claws. By adjusting either the aperture or the shutter speed, the photographer can bring the needle to rest between the claws—a position which indicates that the film will receive correct exposure. Over and underexposure are indicated by the needle being too high or too low.

There are a number of variations on this method of exposure metering, which are similar in their method of operation, but which differ in the way that the meter reading is indicated. In the match-needle type of camera, there are two needles. Instead of lining up one needle between claws in the viewfinder, the photographer aligns the two needles to set the correct exposure. Also common are traffic light displays, where an LED of a particular colour or a certain combination of LEDs lights up when the exposure is correct. Over and underexposure is indicated in this case by an LED of a different colour, or in a different position in the finder, lighting up.

This manual system of exposure sett-

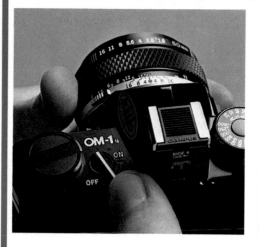

Manual metering-Olympus OM1

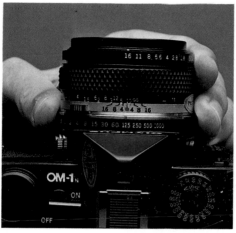

1 Meter on *Manual cameras can be used in two different ways. The procedure in this second example again begins by turning on the exposure meter*

2 Set shutter *Here the photographer is especially concerned that the right shutter speed is set, so he adjusts this control first*

3 Viewfinder *To centre the needle this time the photographer adjusts not the shutter speed control, but the aperture ring*

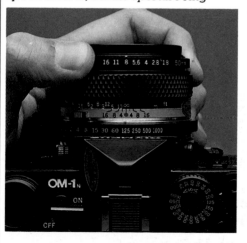

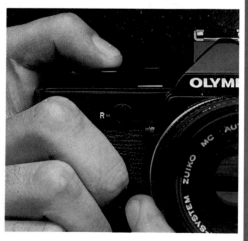

4 Adjusting aperture *Since the photographer considers the f-number to be of secondary importance, he can adjust it freely to balance the meter*

5 Release shutter *If the meter needle is between the claws, the film will receive the correct exposure when the shutter release is pressed*

Exposure compensation *Backlit subjects require extra exposure, and some auto cameras have an exposure compensation dial to provide this facility*

ing, while more time consuming than an automatic system, does allow the photographer full control of the aperture and shutter speeds that are being set, and for this reason is often preferred by professional photographers. It is also marginally cheaper to build into a camera, so is often found on the more inexpensive models in a camera range.

'Programmed' automation
This system, used in cameras at both ends of the price range, has a pre-programmed sequence of apertures and shutter speeds which will be set according to the lighting conditions. In the

Shutter priority-Canon AE1

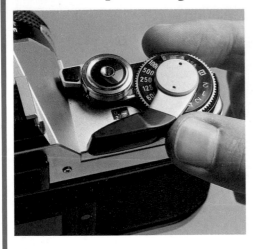

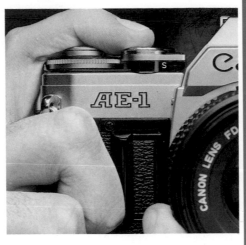

1 Set shutter *On shutter priority automatics such as this Canon AE-1, the first stage is to set the shutter speed to the chosen value*

2 Half press release *Gentle pressure on the shutter release switches on the camera and activates the through the lens exposure meter*

3 Viewfinder *A needle indicates the aperture which the camera has chosen. If this is off the scale, chose another shutter speed*

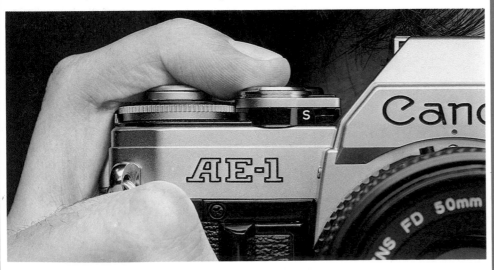

4 Release shutter *When the shutter button is pressed all the way down, the aperture is closed to the value selected by the exposure meter*

brightest light, a fast shutter speed and small aperture will be set by the camera, and as more exposure is required, the camera will automatically change the shutter speed to a progressively slower setting, and open the iris diaphragm to a wider aperture.

In the less expensive cameras, like the Nikon EM, the photographer has no control over the speeds and apertures that are used. Although this system is fine for quick snapshots, it is of limited use for serious photography.

More expensive automatic cameras have manual override, or compensation for unusual lighting. The most common example is the provision of a switch which allows the photographer to use the camera manually, in the same way as any non-automatic camera would be operated. Though this is a useful feature, many photographers find that automatic exposure gives perfect results for 98 per cent of their exposures, and they rarely take advantage of the switch.

The most common reason for wanting to change the exposure that the camera has set is because the subject is backlit, and so the automatic facility on the camera would produce underexposure. This is because the light meter usually averages the light reaching a certain portion of the focusing screen, and is unduly influenced by the bright light behind the subject. Early through the lens meters averaged the light from the whole frame, and produced serious underexposure in backlit conditions. Modern cameras are more selective— many of them have a meter that gives more emphasis to the centre of the screen—and so if the subject is central, backlit pictures will not be quite so heavily underexposed. Some cameras have a backlight switch which gives a one stop overexposure increase when pushed, and others have an exposure compensation dial, which allows the photographer to dial in a pre-set amount of exposure compensation. On cameras that lack either of these facilities, exposure compensation can still be made by changing the film speed set on the dial of the camera.

A few cameras have what is described as a 'memory lock'. This is a switch or button, which locks the meter when pressed. If a backlit portrait is the subject of the picture, the photographer will move in close to the subject, take a meter reading from the model's face, depress the memory lock and then move back to recompose the picture before pressing the shutter release. The camera will give the correct exposure for the model's face, and ignore the backlighting.

The big advantage of an automatic is that you never miss a shot through fiddling with the exposure controls— even if exposure is not perfect, it will be nearly right every time. But there is no doubt that a manual gives you a better 'feel' for exposure and this makes it ideal for the beginner as well as the hardened professional.

What to look for

Once, you know which exposure system you want, you can begin to look at individual cameras.

Many photographers choose a camera from one of the big Japanese SLR systems manufacturers such as Nikon or Olympus. These are of universally high quality and fit into an integrated *system* of lenses and accessories made by the same manufacturer. But if you have a limited budget, or do not intend to build up a system, cameras from the independent makers such as Zenith can be inexpensive and very good value for money.

Before you make your decision, work out precisely what you want from the camera—not only now but in the foreseeable future. Of course, you may find at least a couple of cameras fit the bill perfectly—there is often little to choose between comparable cameras from the systems manufacturers. And ultimately your decision may rest on personal preference. So it is important to try each camera to see which you find most comfortable to handle.

When calculating how much you can afford to spend on your new camera, bear in mind that some important accessories may not be included in the list price. The standard lens may be, but 'extras' such as carrying case and protective filters are not usually included.

Features to look for
Handling—do the controls fall easily to hand?

Weight—most SLRs weigh around 600 g; anything much heavier may be a nuisance if you intend to move around a lot.

Compactness—is the camera bulky?

Robustness—lightweight plastic levers that protrude from the camera body can be very vulnerable.

Shutter speeds—most SLRs have a full range up to 1/1000 second, but a few only give 1/500. For complete action-stopping, it may be worth looking for a camera that gives 1/2000.

Automatic exposure—does it have manual override? If not, is there a back light, exposure compensation or memory lock control? Without any of these, sunsets may be difficult to shoot.

Shutter or aperture priority exposure—aperture priority may be unsuitable for action shots; shutter priority for still lifes.

Viewfinder—is it interchangeable? There are many viewfinders available for special purposes.

Does it have a display system for exposure information: LED, needle or 'traffic lights'?

Does it show the number of frames used?

Flash—hot shoe or socket?

What is the synchronization speed? Most are 1/60 or 1/125 second, but some such as the Nikon FM2 give a sync speed of 1/200, which may be valuable.

Mirror lock—useful for special effects.

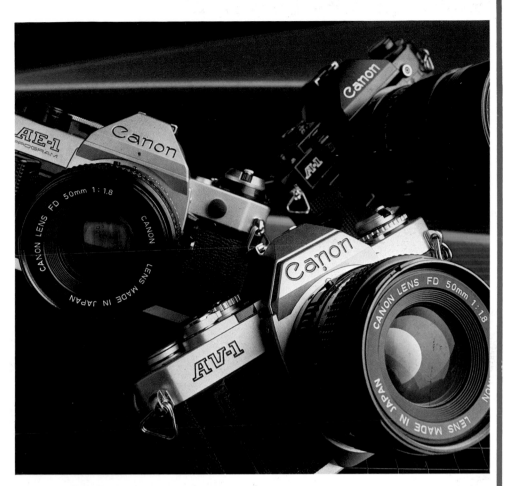

Canon family *Each of the major manufacturers offers a wide range of cameras from the simple to the sophisticated. This picture shows the three automatic SLRs made by Canon.*

Viewfinders *As your photographic skills develop, you may find the facility to use interchangeable viewfinders such as a swivelling eye/waist level finder (left) or a magnifier (right) invaluable.*

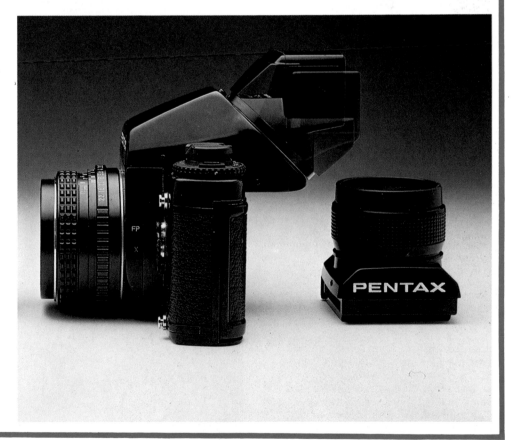

Building an outfit

With such a bewildering array of 35 mm SLR lenses and accessories on the market it can be hard to decide what to buy when and, for many people, building up an outfit is a rather haphazard process. Often they find themselves with an expensive accessory that they hardly ever use while lacking an essential item. To avoid these problems and build up a well-balanced system suitable for all situations, you must plan your purchases carefully.

SLR systems are designed to cater for many different needs and a 'complete' outfit need not include every available accessory. A complete outfit is simply one that suits your needs exactly and no more—it is clearly wasteful to have a complete set of macro lenses if you never do any close-up work.

It is important, therefore, to try and get a clear idea of just what kind of photography you intend to do in the future. If you want to specialize in architectural photography, for instance, the balance of your system should be tipped towards this, and an early purchase should be a shift lens for perspective correction. If your main interest is close-up photography, it is probably worth buying a 50 mm macro as your first lens instead of the standard. Although expensive, the macro can give very sharp, punchy results with close-ups and can also be used for normal photography.

If, on the other hand, your interest in photography is more general, or if you have no clear idea of where you want to go, you should try to build up a versatile, balanced system that can give good results in a wide variety of situations.

Camera and lens

Planning should begin at the outset, when you buy your first camera body. Rather than simply buying the best camera you can afford, think carefully about how you expect your interest in photography to develop. If you never buy any more equipment, then the best you can afford may indeed be the wisest choice. But if you plan to improve your outfit gradually it is important to buy a camera that you can uprate without making all your lenses and accessories redundant. In particular, the lens mount should be compatible with the camera you want.

Essentially, this means buying a camera from one of the SLR systems manufacturers. Although cameras from these manufacturers are generally more expensive, most have an economy model—the Nikon EM or the Olympus OM10, for example—which is often very good value for money. Many lenses and accessories within these systems will suit both the cheapest and most expensive cameras in the range. So when you

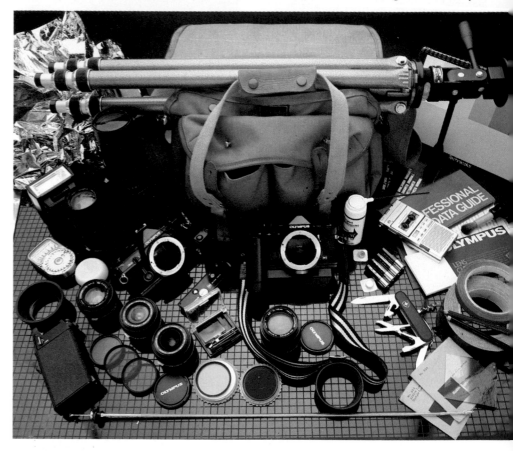

Complete outfit *As well as cameras and lenses this outfit contains many other useful items such as tape, filters, spare batteries, reflecting material, lens brush, tissues, tape recorder, wax pencils and cable release*

eventually want to buy a more expensive camera you can simply buy a new body and continue to use the rest of your outfit.

People tend to automatically buy the standard 50/55 mm lens with their first SLR. But with many cameras, you can buy just the body and then choose the lens separately—the best lens need not be the standard lens. Although often of very high quality, the standard lens is very much a compromise between the coverage of a wide angle and the selectivity of a telephoto. If you never buy another lens, it is perhaps a good compromise, but as soon as you start to acquire additional lenses, you will probably find that you use the standard lens less and less.

A suitable first lens, therefore, might be a medium wide angle such as a 35 mm. This is generally the cheapest wide angle lens in the manufacturer's range and is not so wide as to cause constant problems with perspective. If you anticipate buying a medium telephoto in

Standard filters *These filters are all you need for most situations. They are 81A, 82A, red, yellow and polarizing. Having lenses with the same filter mounts greatly reduces costs. The lenses here range from 24 to 200 mm and all have 49 mm threads*

the near future, though, it would be worth getting a 28 mm or even 24 mm.

Nevertheless, there are two significant drawbacks to the wide angle as a first lens. First, if you have no darkroom or shoot mostly on slide film, it is far harder to take advantage of the facility for composing the picture after processing. Indeed it may be positively annoying—and expensive—if all but a few of your pictures are not perfectly framed at the time of shooting. For experienced photographers, this does not present a serious problem: they can adapt their style to the lens and compose well even with a wide angle lens. But for those only just beginning to develop their eye, it can be far harder composing with a wide angle. Indeed for the newcomer to photography, it is probably better to go the other way altogether and settle on a medium telephoto such as an 85 mm as a first lens. With the telephoto, it is far easier to be selective and fill the frame without moving unnervingly close to the subject.

The second drawback of the wide angle lens is the problem of unflattering perspective for portraits. While this can be overcome simply by moving back and cropping the picture later, it is again better to buy the 'portrait' lens, a medium telephoto, if you intend to take a lot of portraits.

Another alternative is to buy a zoom. A typical wide-to-tele zoom has a range from 35 to 70 mm and may seem to provide a focal length for most situations, giving sufficient coverage for landscapes and, at the other extreme, good perspective for portraits—apparently the ideal compromise. Unfortunately, zoom lenses tend to be bulky, slow—maximum aperture for a zoom may be about f/3.5 compared with f/1.4 for a typical standard—and, most importantly, can cost twice as much as fixed focal length lenses. Furthermore, most photo-

Outfit alternatives *A large outfit is cumbersome and for portability the minimum of equipment is best*

graphers find that they tend to use a zoom only at the two extremes of the zoom range, and rarely use intermediate focal lengths. If you have enough money for a zoom, therefore, it might be better to spend it on a pair of fixed focal length lenses instead, since these will give better quality results.

However, there is a great deal to be said for having just one lens to carry around and, as a single lens, a zoom is very versatile. The zoom can be kept permanently on the camera body and, if you have no other major accessories, your outfit is therefore just a single unit. A single unit is much easier to carry around all the time—you do not even need a gadget bag. And again, for the beginner, using a zoom is one of the best ways of learning to compose in the viewfinder.

So, if you are still developing your eye for a picture and do not intend to

acquire a second lens for some time, a zoom might be a good choice after all. But instead of a wide-to-tele zoom, which will become partially redundant as soon as you buy another lens, think about a medium telephoto zoom, say 75–150 mm. This is ideal for portraits and a range of other subjects. When you do want a second lens, it will be nicely complemented by a wide angle. Remember, though, to look for one of the new generation of lightweight zooms, or the advantage of mobility will be lost—go for speed and lightness rather than a big zoom range.

First accessories

Once you have made your decision and bought your first camera and lens, you may not make another major purchase for some time. But there are a number of small items you can buy that will improve your outfit in the meantime—indeed it

Professional's choice As a general editorial and nature photographer, Peter Kaplan carries a large range of lenses in his outfit. These include a 15 mm super-wide angle, 16 mm full frame fisheye, 24, 35, 85, 180, 200 macro, 300 (f/2.8) and 400 mm Novoflex. The lenses are colour coded so that he can tell at a glance which is which

The all rounder Colin Molyneux uses a car full of equipment when on assignment. But as a basic outfit he takes at least two camera bodies with motors, 20, 55 macro, 80-200 zoom and 300 mm lenses, a perspective control lens, a tripod and an exposure meter. As most of his work is in colour he usually carries polarizing and graduated filters

Chapter 2
FOCUS
Depth of field

Many beginners believe that the idea of focusing is to get everything in the picture sharp, but this is not always possible nor even desirable. No lens can show both very close and very distant objects sharply. Either the close or distant objects must be out of focus. The zone that is sharply in focus is called the depth of field.

The most common way to improve the depth of field is to 'stop down' the lens aperture—that is, reduce the diameter of the lens. The smaller the aperture, the better its depth of field. Remember that small apertures mean large f-numbers.

From this, it follows that if you want to get as much of the picture as sharp as possible, you must always close the lens right down to f/16 or f/22 if the lens allows it. To keep the same exposure, you need a fast shutter speed.

Once the aperture gets smaller than a few millimetres, the picture quality worsens because of the effects of *diffraction* the result of light travelling past obstacles. The same effect is used in another way to create spikes on highlights in pictures. Many lenses can't be stopped down smaller than f/16, since the gain in depth of field would be offset by an overall loss in sharpness.

Another way of controlling depth of field is to use a lens of a different focal length. A

Blurred backgrounds *Using a wide aperture cuts out the background. Stopping down the lens brings it into focus*

telephoto lens has a more restricted depth of field than a standard one, when focused on any particular distance, while a wide angle lens has a greater depth of field. Choice of focal length has as much effect on depth of field as choice of aperture.

How depth of field works
The only reason that a lens has any depth of field at all is that we can tolerate slightly out-of-focus images. Imagine a simple lens focused on an object, as in fig. 1 below.

Never rely on the scale to give sharp results.

Rays of light from an object slightly closer will not be focused exactly on the film, but will focus a little way behind it (Fig.2 below) so the slightly closer object will be out of focus on the film.

But unless you enlarge the film a great deal, and look at it closely, you won't notice that the slightly closer object is blurred. The film itself has a grainy nature, which can make it impossible to tell whether or not objects are sharply focused. These two factors combine to allow a fair tolerance in focus, and the range of sharp focus appears quite wide.

Circles of confusion
The simplest sort of object to deal with is a point of light. A slightly defocused image of a point of light is a small circle, technically known as the *circle of confusion*, rather than a point. The more defocused the image, on either side of the true focus point, the bigger the circle.

Any real object can be thought of as being made up of a large number of points of light, of different colours and brightnesses. Each point produces its own image, and when the image is out of focus all the circles of confusion start to overlap.

Stopping down the lens helps to improve the depth of field because if you reduce the lens's aperture, you reduce the size of the circles

1 *Light from the centre of the subject is brought to a focus at the film plane*

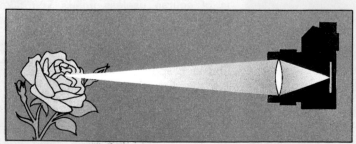

2 *Light from parts of the subject closer to the camera focuses behind the film*

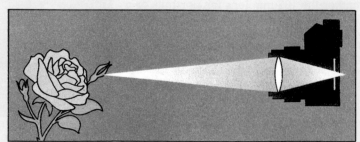

of confusion. So there is a greater chance that slightly out-of-focus images will be acceptably sharp, and depth of field is increased.

Depth of field scales

With most lenses, the depth of field at any setting is indicated by markings on the barrel. Read against the focusing scale, these show how much is in focus at a particular f-number.

The scale shows another characteristic of depth of field – it is greater on the far side of the focus point. This is worth bearing in mind when you are planning your exact focus point.

Never rely on the scale to give sharp results. Since depth of field depends on tolerance to unsharp images and on the graininess of film, the camera manufacturer has had to make an estimate of what people will put up with. If you are being very critical

No depth *A bad choice of focus and depth of field means most flowers are blurred*

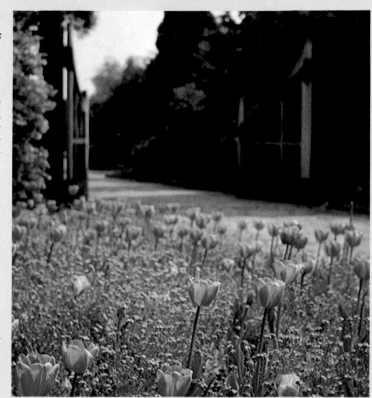

and are using fine grain film, do not be surprised if you get poorer depth of field than the scale suggests. It is only a guide – remember that only one distance can be truly sharp unless you are using special equipment.

On an SLR, it is possible to see the range of focus on the viewing screen. But many cameras these days view the scene at full aperture all the time, to give a bright view and make focusing easier. On such cameras it is an advantage to have a 'depth of field preview' button which stops the lens down instantly to the taking aperture, giving you a picture of the final depth of field. Though this helps a lot, it has the drawback that the screen goes quite dark, making it hard to view. Even so, it is the only sure way to check.

The depth of field scale

Full aperture *At wide apertures there is very little depth of field, and only a small area in front of and behind the distance setting is in focus*

f1.7

f4

f8

5.5 7 10 17 50 ∞

Distance setting **(metres)**

5.5 7 10 17 50 ∞

Minimum aperture *As the lens is stopped down, the depth of field becomes progressively greater. At the minimum aperture, in this case f/22, virtually the whole of the picture is in sharp focus, and depth of field extends to infinity*

f22

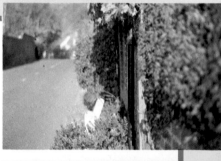
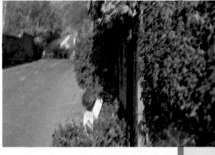
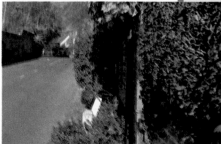

Where to focus

When you first start taking pictures, your only thoughts about focusing are probably along the lines of 'Is it in focus, or is it out of focus?' But it does not take very long before you begin to realize that focusing a camera is not quite that simple.

Unless the subject is distant scenery with nothing in the foreground of the picture, there will always be some objects which are closer to the camera than others. Under most circumstances, you must decide which part of the scene is to

appear most sharp on the film.

In simple cases, such as a figure standing against a nondescript background, the decision of what to focus on will be simple—you can just focus on the figure. But in a more complex situation, where no one part of the subject seems more important than any other, and there is not enough depth of field to include everything it can be difficult to decide what to focus on.

The way you focus the camera must depend on what the picture is for, and which part of the picture is most important. For example, the kind of photograph that an archaeologist requires of Pompeii will be altogether different from the picture that a holidaymaker may take of the same subject. The archaeologist will need a picture that gives the maximum amount of information about the buildings and the setting, whereas someone who is seeing the sights is more interested in

Houses *Attention is drawn to the houses by throwing the foreground out of focus —selective focusing emphasises detail*

Chairs *Careful use of the depth of field and focus point allows comprehensive focus of near and far objects*

Crowd *Isolating a figure. By focusing on a single figure, it is possible to pull one face out of a large crowd*

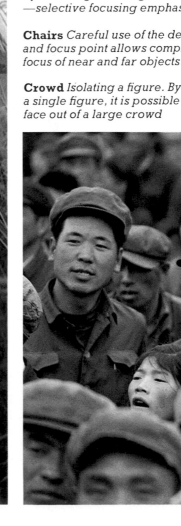

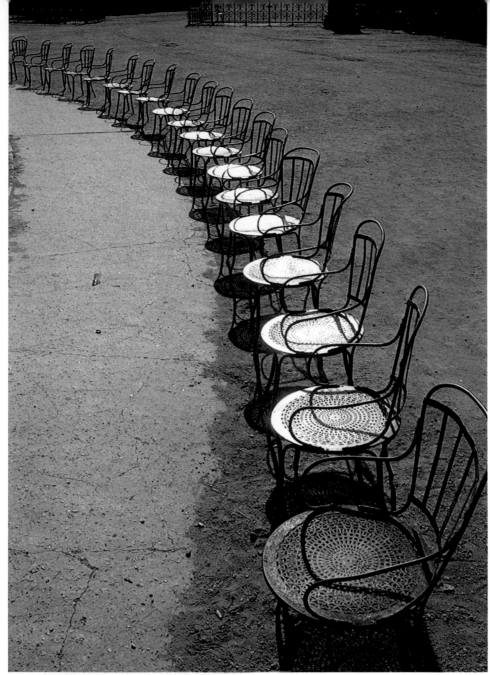

Eyes in focus *Where there is not enough depth of field to keep the whole face in focus, focusing on the eyes alone does usually produce an acceptable portrait*

Unsharp eyes *On the other hand, a portrait in which some other part of a sitter's face is in focus, and the eyes are not, tends to look distinctly odd*

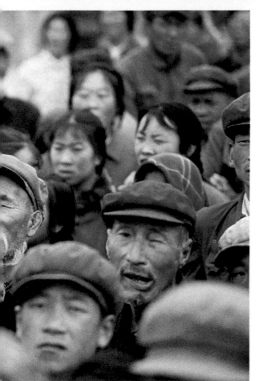

taking a picture which will bring back the atmosphere of the place, than in creating a strictly literal interpretation.

These requirements will dictate what the two photographers choose to focus on. The archaeologist will try to make sure that absolutely everything in the picture appears pin-sharp on the film. He might do this by estimating the distance to the nearest point of the picture, and to the most distant part of the scene, and then consulting the depth of field scale on the lens to focus on a point between these two distances. When the lens is stopped down to a small aperture, both near and far points will be in focus.

The kind of picture that is suitable as an accurate, scientific record will, however, often look out of place in a picture album. Such pictures are often sterile and lifeless, despite their technical perfection. In photographing the same scene, a tourist may well spot a particularly interesting feature of a building and decide to emphasize this, rather than concentrating on getting everything perfectly sharp. In this case, it would be best to focus carefully on the feature that

is to be the centre of attention, and use a wide aperture to restrict depth of field.

What you focus on will depend on which part of the picture is most important, and what you wish to include or eliminate. Do not forget that those parts of the picture which are unsharp are not necessarily wasted. You can use out of focus portions of the image to frame a part of the subject that you wish to emphasize, or to provide an impression of depth in the picture.

The way you focus the camera, and set the aperture to control depth of field, can be divided into *selective focusing*, where you use shallow depth of field to isolate the subject, and *comprehensive focusing* where maximum use is made of the available depth of field.

Selective focusing

It is always necessary to be selective in focusing, so this term is misleading, but it is generally taken to mean the use of shallow depth of field to isolate or emphasize the subject. This may be a decision that is taken for a specific reason—such as a distracting back-

ground to the picture. It may be forced upon the photographer, for example by poor light where it is not possible to close down the aperture of the lens to produce greater depth of field. The subject may be moving quickly, so a fast shutter speed is needed. In order to give adequate exposure, it would be necessary in this case to use a wide aperture.

All modern SLR cameras focus at full aperture, so the image in the viewfinder when you are taking the picture will be more selective than the final picture. Unless you are taking photographs at full aperture, there will be more depth of field when the lens is closed down to the working aperture. If you want to produce a blurred foreground or background, then it will be necessary to close the lens down in order to preview the depth of field. Most manual and semi-automatic SLR cameras allow you to do this, usually in the form of a catch or switch on the camera body. When pressed, this closes down the lens to the working aperture. If you are using a viewfinder camera, there is no alternative to using the depth of field scale.

When shooting portraits, it is very useful to be able to eliminate a background, particularly if the pictures are taken in a city setting where it is often difficult to find an attractive backdrop against which to take the pictures. A telephoto lens (which has very shallow depth of field) will do this more effectively than a standard lens, and the opposite applies to wide angle lenses. These have more depth of field, and consequently are not as useful when using selective focus techniques.

In most cases, the rule of thumb 'focus on the most important part of the picture' will apply, but there are one or two instances where this will not give you enough guidance about what part of the subject to focus on. If, for example, you are shooting portraits at a wide aperture, depth of field is often so shallow that only part of the subject's face will be in focus. In this case always focus on your sitter's eyes, unless you have a particular reason for wanting the eyes out of focus. Sur-

prisingly, a portrait in which only the eyes are in focus will often be acceptable, whereas one in which only the tip of the subject's nose is sharp will look ridiculous.

For certain types of portrait shot this rule could be broken successfully. One instance would be a picture of a potter or other craftworker. Here you might choose to focus on the hands, and let the whole face fall outside the depth of field of the lens. This would draw attention to the hands at the expense of the subject's face.

If you are photographing a landscape which seems to lack a focal point, you might consider focusing on an isolated tree or wall in the foreground, and using a wide aperture. This would confine attention to one part of the picture by the use of selective focusing. It would also

Centre of interest *With no obvious subject matter, choose a feature which will most attract the attention in a scene*

prevent the viewer's eye from wandering all over the picture, as it might if you were to adopt the more obvious solution of focusing on the scene behind.

A background or foreground does not have to be in perfect focus in order to set the scene of a picture, and by isolating the main subject using selective focusing, the surroundings can give an impression of the setting without being so clear in the picture as to intrude. Images of cars and buildings in a city street do not have to be absolutely sharp in order to be recognizable, and will still add atmosphere to a picture in which the principal subject is isolated by selective focusing.

Similarly, photographs in a garden do

Groups of people *When there are large numbers of people in a picture, it can often look cluttered. By focusing on one figure, the beach scene becomes a backdrop, and the soldier ceases to be so anonymous*

not have to show every flower head sharply drawn in order to get across the idea of flower beds. Out of focus flowers will appear as blobs of bright colour which do not draw attention away from the gardener in the middle of them.

Comprehensive focusing

Once you know a little about depth of field, obtaining sharp focus throughout the picture seems an easy matter, but it depends as much on where in the picture you focus as it does on the aperture that you use. Ironically, when photographing a distant scene the best point on which to focus is not infinity.

If you are taking pictures at a medium aperture such as f/8, and you focus the lens on infinity, depth of field will extend from a point closer than infinity, around nine metres on a standard lens, to some point beyond infinity. Any depth of field that extends beyond infinity serves no useful purpose. You can achieve maximum depth of field by focusing on a point closer than infinity. This brings the near point of sharp focus closer to the camera, while still keeping the far distance sharp. If the furthest point in focus is infinity, the lens is focused on what is called the *hyperfocal distance*. This is different for each aperture on a lens. Though it is never marked on the lens barrel, it is easy to locate—just align the infinity marking for the lens with the depth of field mark for the aperture in use, and the lens will be focused on the hyperfocal distance. For a scene that includes infinity, this will give maximum possible depth of field.

To get the maximum possible depth of field in a picture that does not include infinity, do not simply focus on a point, because there is always more depth of field —usually about twice as much—on the far side of the point of sharpest focus than there is on the near side. The best place to focus the lens is about one third of the way between the nearest point that has to be sharp, and the most distant point.

Wide angle lenses have much more depth of field than standard lenses. A 28 mm lens, for example, when stopped down to f/22, will give sharp focus from 0.6 m to infinity when focused on a point about 1.3 m from the camera. This extra depth of field can be useful in situations where it is difficult or impossible to focus, such as in a dark room when using flash.

Focusing problems

There are many situations in which you cannot focus through the lens. Sometimes the subject of the picture is reluctant to be photographed, or is camera-shy, and freezes when a camera is pointed at him. There are a number of ways of getting round the problem besides using a wide angle lens at a small aperture. The most obvious solution is just to estimate the distance and set it on the focusing scale of the camera. If your estimates are not accurate, you could try focusing on another subject the same distance away then turn to your original subject and release the shutter.

SLR cameras are particularly difficult to focus when used in low-light conditions, or with wide angle lenses, and these are situations where rangefinder cameras excel. If you are using an SLR much of the light that enters the camera lens is absorbed by the viewing system —the mirror, prism and viewing screen. In bright light, this does not matter, but when the light gets dim it becomes in-creasingly difficult to focus this kind of camera. If a wide angle lens is fitted, the point of sharpest focus is often hard to locate precisely.

Unfortunately, you cannot rely on the split image focusing aid incorporated in the viewfinder of many modern SLRs (see panel) to help you in low light situations—they partially black out if there is insufficient light.

How to focus

Split screen focusing 1 *Tiny prisms break up the out of focus image*

2 *The broken up image becomes smooth when the subject is in focus*

With non-reflex cameras, the lens is focused by estimating or measuring the distance to the subject and then setting this on the focusing ring. With an SLR, however, you can see the scene through the lens itself. This means you can set the focus visually, adjusting the focusing ring until the subject is sharp in the viewfinder.

To focus the lens, look through the viewfinder at some clearly visible detail in the chosen subject. Then slowly turn the focusing ring one way or the other until the detail is pin sharp. The lens is now focused.

This may seem laborious at first, but you will soon find that, with practice, you can focus almost instantaneously. And providing your eyesight is good, or you use the proper corrective eyepiece, your pictures should be perfectly sharp every time.

Nevertheless, it can be difficult to focus a wide angle or standard lens in this way and most SLRs now include some type of focusing aid in the viewfinder. These are of two main types: split image screens and microprisms.

Split image focusers

The split image focuser is simply a way of showing you more clearly when the rays of light from the subject converge precisely on the focusing screen—that is, when the image is in focus. It consists of two tiny wedge-shaped prisms set into the focusing screen and relies on the way prisms bend light for its focusing effect. The two wedges slope in opposite directions, but cross in the middle at exactly the same height as the focusing screen.

When the image is in focus, the light rays converge at the same place as the prisms cross over. So the light is bent equally by each prism and the image seen on the two halves of the focuser match. When the image is out of focus, the light converges either behind or before the crossover. Either way, the images in each prism are displaced in opposite directions.

Focusing with a split image. Split image focusers are very easy to use and make focusing considerably more accurate. Simply look through the viewfinder at the small circle on the focusing screen and turn the focusing ring in the way described above for unaided focusing. With the subject out of focus, the images in each half of the circle are offset. To focus, keep turning the focusing ring until the two images mate perfectly.

A point to remember with split image focusers is that they need a lot of light to work properly. If there is insufficient light coming through the lens, either one or both halves of the circle will black out. Generally speaking, they will not work at apertures of less than about f/4, even in fairly bright conditions. So this renders them inoperative with many telephoto and zoom lenses which have a maximum aperture of less. And even with a large aperture, they will not work in very low light conditions or with a dark subject— often just the times when you need them most. If you find that half of the screen *does* black out, you may be able to make it reappear by moving your eye around. But in many situations, even this will not work.

Consequently, the focusing screens of many modern SLRs include a microprism focusing aid as well. This is the shimmering ring around the outside of the split image circle. Some cameras have microprisms alone.

Microprisms

Microprisms work on much the same principle as split image focusers, but instead of using two prisms, they use many hundreds. They are so small that they cannot be resolved by the eye, but when the image is out of focus they appear to shimmer. This is due to multiple splitting of the image. When the image is focused, the microprism clears, giving an undistorted view.

Chapter 3
ALL ABOUT EXPOSURE
Exposure basics

One of the first things a newcomer to SLR photography needs to know is how to get the correct exposure—that is, how to set the shutter speed and aperture controls so that the film receives just the right amount of light. Even if exposure on your camera is automatic, it is worth knowing a little about it—auto mechanisms can be wrong, and there may be shots that justify using manual controls.

Exposure probably causes more problems for the photographer than any other area of technique. So do not be put off if you find many of your early pictures come out badly. Even hardened professionals often *bracket* their exposures—they repeat the shot at settings either side of the estimated exposure to make sure they get one good picture. Once you know the basic principles and think before you shoot, you should get good results most of the time.

What is exposure?
Beginners are sometimes confused by the way the word 'exposure' can mean different things. 'Making an exposure', for instance, can simply mean taking a picture. Or when someone asks, what 'exposure' you gave a picture, they may just want to know what aperture and shutter speed you used. After a while, you will be able to judge what is meant from the context. Here, we usually use the word 'exposure' in its strictest sense, to mean the amount of light the film receives while the shutter is open.

To give a good picture, the film must receive just the right amount of light. If it gets too much light—that is, if it is *overexposed*—the photograph will be too light as well. All the brightest areas (the highlights) will be washed out and detail will be lost— even the shadows may be very pale. If the film gets too little light (*underexposed*), the picture will be dark and no detail can be seen in the shadows. Only if the film gets just the right amount of light will detail be visible in both the highlights and the shadows, and all the colours and tones will be full and bright.

Controlled exposure
Unfortunately, the amount of light available varies from scene to scene. In a camera without aperture and shutter speed controls (such as a simple snapshot camera), a shot on a very bright sunny day might be overexposed, while a very dark scene would be underexposed. So you can only shoot in perfect conditions.

With an SLR, you use the aperture and shutter speed to control the amount of light reaching the film so that no matter how bright or dim the scene is the film always receives the right amount of light.

The aperture controls the rate at which light passes through the lens and onto the

Using aperture to control exposure

relative area = 1

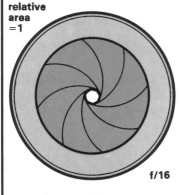
f/16

2

f/11

4

f/8

8

f/5.6

At f/16, the whole image is much too dark

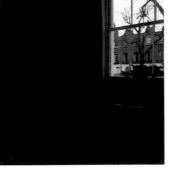

The view outside is correctly exposed at f/11

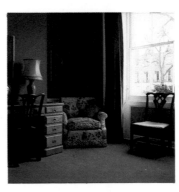

There is a little detail visible indoors by f/8

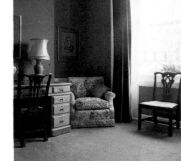

The best picture is produced by using an aperture of f/5.6

film. The shutter speed determines how long the light has to act upon the film.

With a wide aperture, a great deal of light comes through the lens; with a slow shutter speed, the light comes through the lens for a long time. So with a wide aperture and a slow shutter speed, the film receives a high proportion of the light in the scene being photographed. With a narrow aperture and a fast shutter speed, the converse is true.

So for a shot in really dark conditions, you need a wide aperture and slow shutter speed. For a very bright scene, you need a narrow aperture and a fast shutter speed. Most shots fall somewhere between these two extremes.

Metering

To set the right shutter speed and aperture combination, you must assess the brightness of the scene you want to photograph. In the past, photographers often relied on experience to judge the brightness of a scene. This method is unreliable since the eye can easily be fooled—and, of course, the

beginner will hardly know where to start.

Nowadays, however, nearly every serious photographer uses a photo-electric light meter. Most modern SLRs incorporate this within the camera and it measures light coming Through The Lens (TTL).

With automatic cameras, the exposure controls are adjusted automatically according to the light meter reading. With semi-automatic cameras, you set either the shutter speed or the aperture, and the camera does the rest. With manual cameras, you set either the shutter speed or aperture and then adjust the other until a signal in the viewfinder tells you you have the right setting (see page 12).

Light meters have taken much of the sweat out of exposure and help achieve good results most of the time. However, they are by no means infallible.

The problem is that many scenes contain not just one brightness but a whole range of shadows and highlights. So an exposure setting that is correct for one part of the picture may not be correct for another. A TTL meter will

only tell you how much light there is in the scene altogether—that is, it will give an average reading for the whole frame, though most are biased towards the centre (*centre-weighted*).

If the scene contains a very bright area right near the centre of the frame, it will give a reading that severely under-exposes the rest of the frame. Later chapters show how to cope with this problem (see page 38 and 44). But it is important to remember, particularly when dealing with subjects with extremes of light and dark or light or darkly coloured objects.

Reciprocity

The important thing to remember when choosing the aperture and shutter speeds is that their effect on exposure is *reciprocal*—that is, when you increase one you must reduce the other by the same amount to give the same exposure.

Fortunately, the click stops on both the aperture and shutter speed controls are stepped to avoid any complex calculations. A stop movement on either control either doubles or halves the

exposure, depending on which way you turn the control.

So if you alter the shutter control to a slower speed by one stop, this doubles the exposure time. You can compensate for this by halving the aperture by taking it down a stop. So if the correct aperture with a shutter speed of 1/125 second is f/2.8, the correct aperture at 1/60 second is f/4; at 1/30 it is f/5.6 at 1/15 it is f/8, and so on.

If you stop down the aperture by three stops—say from f/2.8 to f/8—to give better depth of field, you must remember that the shutter speed will have to be three stops slower to give the same exposure. Now, as the following chapter shows, it is often important to maintain a high shutter speed. It may be then that the loss in shutter speed has a more significant effect on the picture than the gain in depth of field. In this case, then, it would be better to use shutter speed/aperture combination that gives a high shutter speed while sacrificing depth of field. You must choose the combination that best suits the subject. This is the true art of exposure.

16 32 64

f/4 f/2·8 f/2

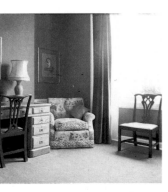

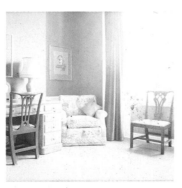

Even at f/4 the picture is just about acceptable

At f/2.8 the image is quite clearly overexposed

At full aperture, the picture is totally useless

Apertures and f-number

Although *f*-numbers seem an odd way of marking apertures, there is a good reason for the use of the system. The *f*-numbers describe the aperture of the lens—that is, the diameter of the lens opening.

Now, the reason the photographer is concerned with the diameter of the lens opening is because it controls the amount of light that passes through the lens. However, the amount of light passing through the lens also varies with the focal length of the lens (see page 58)—a long lens lets through less light because it accepts light from a smaller angle than a short focal length lens. So the effect of a particular aperture varies with the focal length of the lens.

The *f*-number system saves having to recalculate the exposure every time you change lenses. The *f*-number is simply the focal length of the lens divided by the diameter of the aperture. With an aperture of 25 mm, the *f*-number on a 50 mm lens is f/2. f/2 on a 100 mm lens would give an aperture of 50 mm, if the lens could accommodate it.

Shutter speeds

Probably more shots are ruined by using a wrong shutter speed than by anything else. Whether you own a simple instant-load camera or an expensive automatic, your pictures can easily be spoiled by movement of either the subject or the

aperture must be used to achieve correct exposure. This may or may not be a problem, depending on how much light there is and how much depth of field (a wide aperture gives least depth of field) you need for the picture. For this reason

it is useful to know what minimum shutter speed is needed to freeze different types of action.

To be absolutely certain of eliminating shake when you are hand-holding your camera, you should use a shutter speed not slower than 1/125 second when using the standard lens. This is the 'safe' speed: with practice, most people can success-fully hand-hold a camera perfectly steady at 1/60, even 1/30 or 1/15.

You also need to take into account the conditions in which you are taking photo-graphs: it is surprising how much unsteadiness is caused by strong wind. Not so surprising is that being on a boat or in a car or aeroplane inevitably causes camera shake. So if you are in doubt about hand-holding the camera, use 1/125 or faster to be sure.

One catch: if you are hand-holding a long focus (telephoto) lens its magnifi-cation will exaggerate camera shake. This means using a faster-than-normal shutter speed, and for 35 mm camera users there is a useful rule of thumb for calculating this: you simply match the speed to the focal length of the lens being

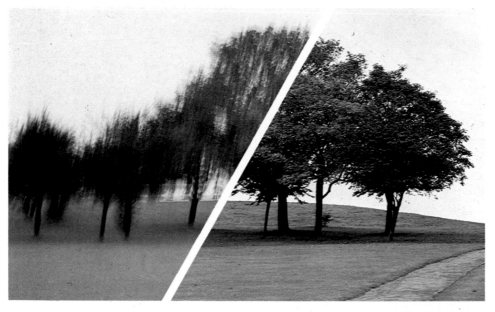

camera.

Whatever type of shutter your camera has, its job is simply to open and close briefly to let light on to the film for a pre-cisely known length of time. This interval —usually known as the exposure time or simply the shutter speed—is a tiny fraction of a second.

Newcomers to photography often find it hard to believe that anything at all can happen within, say, 1/125 second; but happen it can, for if the subject or the camera moves during this fraction of a second, the image may register on the film as a blur.

If the blurring has been caused by camera movement (usually called camera shake), it will be noticeable all over the photograph. No part of the picture—neither subject nor background—will be sharp. If the blurring has been caused by only the subject moving, the background, or at any rate some other part of the picture, will be sharp while the subject will be blurred.

Camera shake is cured either by putting the camera on some suitable support, or by using a fast enough shutter speed. Subject movement can be cured only by using a sufficiently fast shutter speed.

Put like that, it sounds easy; but of course there is an in-built snag to using fast shutter speeds: the exposure time is shortened and therefore a wider lens

Camera shake
Two hand-held shots of the same subject. One, taken at 1/15, failed to eliminate camera shake. The other, at 1/125, is perfectly sharp

Porch *Though hand-held at 1/30, this view taken using a wide-angle lens is acceptably sharp. Any blurring caused by camera shake is not visible on the small scale image*

Church close-up
A telephoto view from the same spot as the picture above, again using 1/30. It shows noticeable blurring as the increased focal length tends to magnify any camera shake. A speed of 1/125, or preferably 1/250, is needed

A still subject *Photography indoors without extra lighting often calls for the use of slow shutter speeds—in this case 1/30—as long as the subject is not moving*

Rice field *With slow films and a subject with little movement, 1/60 is an acceptable shutter speed in poor lighting conditions*

Walking subjects *Unless the subject is very close, 1/125 is adequate to prevent blurring in horizontal movement, such as in a shot like this*

used. With a 1000 mm lens, you need 1/1000 second; with a 200 mm lens, 1/200 (or 1/250) will do. This rule gives about 1/60 second as the slowest speed for the camera's standard lens.

The reverse is also true—wide angle lenses are much easier to hand-hold, so if you are forced by poor light conditions to use a slow shutter speed, a short focus lens is more likely to give you a sharp result.

Holding the camera steady

In theory, supporting a camera on a suitably robust tripod or stand completely eliminates camera shake, freeing you to use whatever shutter speed you wish. Obviously for long exposures, close-up or studio work, a tripod is vital, but many photographers do not realize that it is in any case a good idea to support the camera whenever possible.

If you are at all worried that you cannot hand-hold, make use of doors, fences, walls, posts—in fact, whatever is to hand —as a support for the camera. Stand with your feet apart but do not tense yourself. Squeeze the shutter gently rather than jab at it. According to your own preference, release the shutter while holding your breath, or just after exhaling. This can make a noticeable improvement to the sharpness of your pictures.

With a reasonable range of shutter speeds—this is generally taken to mean speeds of up to 1/500 or 1/1000—freezing subject action presents few problems. But a more restricted range of speeds— or lack of light on a particular day—does not prevent you photographing moving objects, though you must be aware of problem subjects.

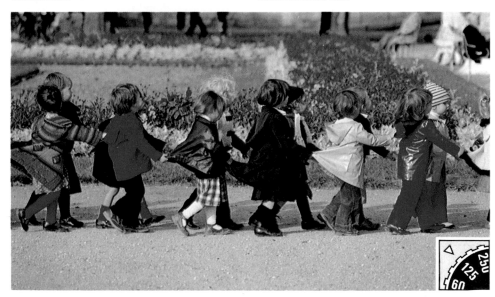

Frozen diver *If the shot is timed to coincide with the peak of action, even fast movement can be stopped using a shutter speed of 1/250*

Can you choose your shutter speed?
The very simplest and cheapest cameras have only one shutter speed—usually around 1/90 second. This is adequate for general photography, and usually prevents blur due to camera shake. Rapidly moving objects, however, will be blurred; so your photography is restricted by such a camera.

An increasing number of modern automatic cameras give you no indication of your shutter speed, but instead just warn you by means of a light in the viewfinder when the shutter speed will be less than, say, 1/30 second. You can control the shutter speed by varying the camera's aperture so that the auto-control will be forced to change the shutter speed accordingly to give a good exposure. But you will not be certain of the speed chosen, so for good results auto exposure can be a drawback.

Fireworks *A time exposure on 'B' of several seconds is sufficient to record several firework bursts. The time depends on the film and lens aperture*

How to choose

When working out the right choice of shutter speed, a useful first step is to ask yourself what sort of movement you are shooting. If it is a normal movement, such as walking, you can work in the region of 1/125 provided the action does not take place too close to the camera, or directly across the field of view. With violent action—the hurdler, the child on a see-saw, the pole vaulter or the motor cycle scrambler—the slowest you can work at will be 1/250.

Many modern cameras have a range of shutter speeds that goes up to 1/1000, and sometimes 1/2000 second, but for certain types of action, such as a nearby car, or a skier hurtling across the frame, even these will not freeze it absolutely.

There is no need, however, to put the camera away when faced with this type of situation. Much of the point of taking action photographs is, after all, to convey the feeling, the visual impression, of action—and in this, a little blurring is a positive help. The secret here is to use the technique known as *panning* : following the subject's movement within the viewfinder and releasing the shutter while continuing to swing the camera so it tracks the subject movement—even after taking the shot.

Done properly, this results in a sharp, or almost sharp, subject against a blurred background. Only those parts of the image which move smoothly will register

Statue and flag *Although the main part of the subject is not moving, a very rapid 1/500 is necessary to halt all movement of a thrashing flag*

Frozen spray *To 'freeze' movement such as the spray in this shot, use the fastest speed of your camera, ideally 1/2000. Any less may give blur*

The first thing to bear in mind about subject movement is that it only matters when it results in movement across the film. This means that if a car is speeding straight towards you at 50 km/h, to a camera it will appear as if it is hardly moving at all, and register quite sharply on film if you only use 1/60. If, however, it is moving across the camera's field of view, then its speed will be only too apparent. To be certain of freezing it, you will need to use 1/500 or 1/1000.

But if the same car moving across your field of view were 100 metres away, rather than 5 metres away, its movement would be much less apparent, and you could safely use a slower speed.

Finally, if the same car were coming towards you diagonally, its movement would be less apparent than when moving straight across. In this case you would probably freeze the action at 1/250 even if the car was close.

As before, long focus lenses exaggerate the effects of movement, while short focus lenses reduce them. There are formulae for working out the appropriate shutter speed for all subjects with various lenses, but they are not usually to hand when you are faced with a particular problem. The only way to be sure of good results is to use common sense and experience—after a while you will be able to do this automatically.

Snow buggy *You can use relatively slow speeds if a fast-moving object is coming towards the camera—1/60 was sufficient in this shot*

Racing car *By using the technique of panning, moderate speeds such as 1/125 can be used even for fast subjects*

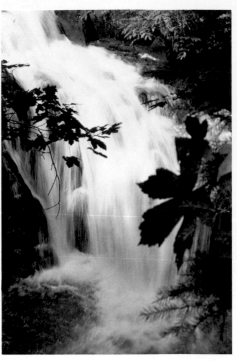

Waterfall impact *The sheer power of the water is suggested by using a brief shutter speed to freeze all movement in the subject*

Flowing waterfall *In marked contrast, but no less effective, is the result of using a slow speed (1/4 or longer) to indicate movement in the subject*

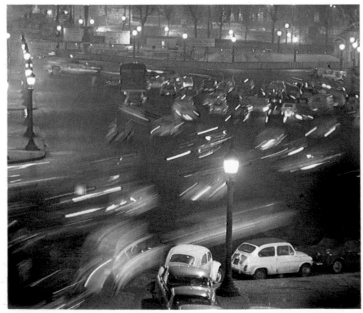

Cyclist *If you keep your camera still and use a fairly slow shutter speed, any subject movement is likely to show as blurring*

Traffic trails *You need to use slow speeds and time exposures for shots at dusk or at night. Trails formed by the lights of moving traffic can look particularly effective. A continuous trail requires use of long exposures and a really firm camera support*

sharply: a galloping horse, for example, will come out with a sharp body, but blurred legs. However, the impression of speed given by a blurred background, or smudged hooves, can be the making of a fine, atmospheric shot. The best way to pan is with the camera on a tripod with a *pan and tilt* attachment but with practice excellent results can be achieved by hand.

Sometimes it is better to hold the camera still and allow the subject to move, so that its image is just a blur. While this can be effective, it doesn't always work: it depends on the amount of detail that remains. But the principle is always worth bearing in mind: you need not necessarily 'freeze' a moving subject for the most effective shot.

Long exposure times

The shutter speed dial of your camera has many speeds on it which most photographers hardly ever use—those longer than 1/30 second. These speeds almost always require the use of a tripod, but they can give exciting results when used properly.

Times between 1/30 and 1 second are invaluable when lighting conditions are poor and there is not much movement in the subject. Additionally, they can be used to create the impression of movement in comparatively slow subjects, such as people walking.

For exposure times longer than a second you must use the 'B' setting. The 'B' stands for 'bulb'—recalling the days when all exposures were made by opening the shutter for a period of time, with an air bulb and flexible tube for vibration-free operation.

A remote release—either the air bulb variety or a cable release—is very useful for operating the shutter without jogging the camera. Exposures can range from a few seconds to several minutes, depending on the subject and the amount of light which is available.

Every now and then, just as the light is fading, you come across a potentially beautiful picture—a group of children playing in the twilight under the boughs of an old tree or fishermen mending their nets in the shadow of the harbour wall—but when you check your meter, you find that there just is not enough light for the shot, even at full aperture and with as long an exposure as you can manage without a tripod.

The moment is lost, but it need not have been; with the right *speed* of film there would have been no problem. A faster film gives you that bit of extra film sensitivity to shoot in very low light. At another extreme, in bright sunlight, a slow film can be just as valuable, giving all the control over depth of field (see page 20) and all the fine detail you need for a high quality picture. Learning to use the right film speed for each situation can make a tremendous difference to the range and quality of your photographs.

Choosing the speed

With a basic cartridge-loading camera, you have little choice of film speed—there is often just one film of each type—black and white, colour negative (for prints) and colour reversal (for transparencies). This film performs well over a remarkably wide range of conditions but there is no scope for using different film speeds for different effects. Once you graduate to a 35 mm SLR, however, a wide range of films of various speeds is available and many possibilities open up.

Film speed is a property of the thin

Slow film *In bright, clear weather, use a slow film to give really full colours like those in the picture*

Fast film *When there is little light available shots like this could be impossible on anything but fast film*

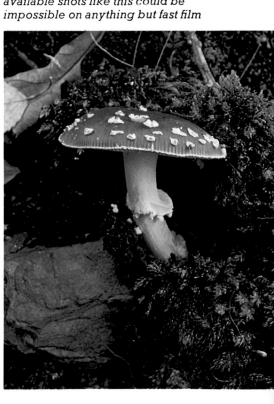

coating of light sensitive *emulsion* on the film that reacts to record the image when you open the shutter. You can see the emulsion by looking along a strip of negatives. One side of the film is glossy and smooth but the emulsion side is dull and very slightly less smooth.

With a fast film, the emulsion is very sensitive and reacts rapidly to light once the shutter is opened. A slow emulsion, on the other hand, is much less sensitive and reacts slowly to record the image. In any situation, therefore, a slow film needs much more exposure than a fast film. You get this extra exposure either by increasing the aperture or using a longer shutter speed.

Alternative ratings

The speed of a film is indicated by the film speed rating marked on the package and on the cassette. Various speed rating systems have been devised, but most films are still marked with numbers according to both the ASA (American Standards Association) and the DIN (German system) standards. These ratings are established by the amount of exposure needed which in turn depends on the film's speed or sensitivity.

There is now also an ISO (International Standards Organization) rating for every film, which is identical to the ASA and DIN speeds and simply combines the two numbers. Thus a film rated 400 ASA and 27 DIN is rated ISO 400/27°.

Most people prefer to use the ASA number because it is far simpler to convert into exposure requirements. With the ASA system, the speed number is arithmetically proportional to the film's sensitivity. That is, doubling the ASA number doubles the sensitivity. If the film is twice as sensitive, it needs half the exposure. One way of halving the exposure is to double the shutter speed. Another is to halve the aperture. Because every increase in *f*-number halves the aperture, halving the exposure simply means taking down the aperture by one stop.

Fortunately, if your camera has a light meter, you won't have to make this cal-

Tone and contrast *Scenes like this need a slow film to bring out the subtle tones and enhance the contrast*

Black-browed albatross *When using a long telephoto, fast film allows you to set a high shutter speed to avoid blur*

culation every time you change films. You simply reset the film speed dial and use the meter in the normal way.

There is a bewildering variety of films on the market, each with its own characteristics and capabilities, but they can be divided into five broad groups according to their speed: fast, very fast, medium, slow, and very slow.

Using fast film

Fast films are rated at anything from 200 ASA upwards. A particularly popular speed with all types of film—black and white, colour reversal, and colour negative—is 400 ASA.

It is in low light conditions that a fast film really pays off. With its extra sensitivity, it can allow you to shoot normally when there is not enough light available to take your picture on a standard medium speed film without very long exposures or wide apertures.

This quality is particularly valuable on dull, rainy days or in European winters where cloud and low angle sunlight reduce the amount of available light. Often the only way to continue your photographic activities throughout the year and take advantage of the abund-

ance of highly photogenic material that occurs in winter is to use a fast film. Many of the beautiful atmospheric pictures of misty winter scenes or frosty puddles will probably have been taken on fast films. Indeed, unless you are fortunate enough to live in a climate that is sunny all the year round, it is probably a good idea to keep your camera loaded with a relatively fast film in winter.

Similarly, indoor photographs by available light are rarely possible on standard film without extreme exposures. Usually flash or photographic lights are needed, either of which can ruin the lighting effect or spontaneous event you were trying to capture—and they cost money. By using a fast film you may not only be able to shoot indoors by available natural light during the day, but also by the normal room lights at night.

If you do shoot with a fast film in artificial light, though, remember that

Texture *On anything but a fairly slow film, the fine textural details on Ayers Rock, Australia, would be lost*

colour slide films are balanced for either natural or artificial light. If you use a daylight film in artificial (electric) light, the final photograph will have a distinct colour cast.

Another big advantage of fast films is that they allow you to use a higher shutter speed. This can be useful even when conditions are good enough for a slower film. With a fast film, the shutter can be set at 1/500 second or even 1/1000 second for freezing fast moving action, while a sufficiently wide aperture is retained for good depth of field. If you are photographing sport on anything but the brightest day, this can be invaluable.

Alternatively, you can take advantage of the higher shutter speeds available with fast films under any conditions to reduce the chances of camera shake. When using a hand-held telephoto lens in particular, you can easily get severe camera shake, but changing to a fast film may give you the extra shutter speed to avoid this becoming too obvious. A faster film may also be valuable with a long telephoto anyway because of the tiny maximum aperture.

With so many points in their favour, you may wonder why people do not

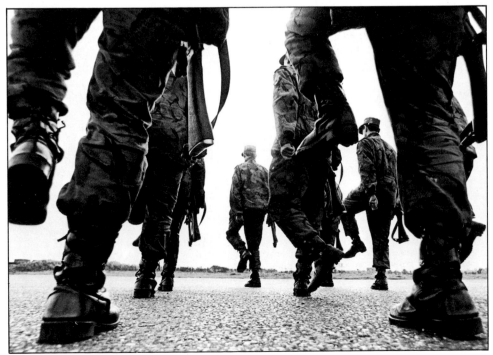

Depth of field *With a fast film, you can get good depth of field and fast shutter speeds even on a dull day*

Medium speed film *In changeable weather load the camera with medium speed film to cope with all conditions*

shoot with fast films all the time. Indeed some photographers do. But, like every type of film, fast films do have their disadvantages.

One of the most significant drawbacks of fast film is reduced picture quality. Fast films not only give a *grainier* image than slow films, but they also tend to suffer from lack of contrast.

With a grainy image, sharpness is necessarily poor because outlines are coarse and less well-defined. Study an enprint made from a fast film through a magnifying glass and you can see what appears to be the individual grains—though in fact the effect is caused by the clumping of individual grains.

If you only intend to make small prints from the negative, this extra graininess does not really matter. However, as the picture is progressively enlarged, the grain pattern and poor definition become more and more obvious. So if you want really large prints, it might be better to use a slower film if at all possible. With really fast conventional film (see panel), the grains can be so big that they are easily visible to the naked eye even at fairly small enlargements. Such coarse grain can sometimes be used creatively and even heightened deliberately for special effects, but the reduced image quality is generally undesirable.

Similarly, the softness of the slightly lower contrast negative of high speed

Very fast films

Sometimes, when the light is very poor, you may find that a standard fast film is inadequate. In this case you could use one of the special high speed black and white films that are available. These can be rated at 1600 ASA or above.

Although 1600 ASA sounds very fast, it is only worth two more stops than a standard fast film like HP5. A 1600 ASA film, therefore, will not enable you to take pictures in very dark conditions, such as a dimly lit road at night. But it may give you the extra latitude to shoot at the aperture or shutter speed you want, or to use a telephoto lens in gloomy conditions.

There are two basic groups of very high speed black and white film: conventional films and 'chromogenic' films. Conventional very fast films such as Kodak 2475 professional recording film give very

grey and grainy results when rated at 1600 ASA. An alternative is to use a slower film such as HP5 or Tri-X and 'uprate' it by increasing the development time. This tends to give burnt out highlights with lost shadow detail. The left-hand picture was taken on HP5, which is nominally 400 ASA, developed to give 1600 ASA.

Chromogenic films such as Ilford XP1 and Agfapan Vario-XL, on the other hand, work in a different way from conventional emulsions and can be rated at anything between 400 and 1600 ASA. At their rated speed they can give excellent performance, with much finer grain than a conventional very high speed film.

Chromogenic films are, however, more expensive than conventional ones and require more complex processing.

The picture on the right was taken on Ilford XP1, also rated at 1600 ASA.

films can sometimes be attractive, but it certainly reduces their usability. Where there is little natural contrast in your subject, such as in a landscape on a wet day, you should use a slow film if possible to bring out what contrast there is. High speed colour films also tend to give slightly less than the full value to colours, and for really strong *colour saturation*, a slow film is necessary.

While fast black-and-white films suffer from lack of definition, however, there is hardly any difference in sharpness between the standard and fast emulsions of many colour negative films, though there are no colour films anything like as fast as the fastest black-and-whites. Unfortunately, colour films are generally much less sharp than their black-and-white counterparts in the first place, since colour emulsions are made from a sandwhich of three layers. Each layer has its own grain structure and these tend to overlap and diffuse the final image, reducing its sharpness.

Fine grain

Nevertheless, for really high quality work in both black-and-white and colour, particularly if the picture is going to be much enlarged or reproduced, a slow film with fine grain and high contrast is essential. Unfortunately, because such films are less sensitive, they need either a great deal of exposure or bright light.

Most of the high quality still life pictures used for large colour advertisements are taken on slow, very fine grain film. The extra exposure is usually obtained not by opening the aperture wide, since this might reduce depth of field too drastically, but by using very long exposure times. For this, a tripod is absolutely essential. Any still life is probably best done in this way if you want high quality results. The process requires some time and effort, but the final picture should justify all the work.

Out of doors, stationary well-lit subjects with subtle shades of colour, minute details or interesting textural qualities benefit from the superb colour saturation and fine definition of a slow film. In fact, wherever conditions are bright enough to permit the use of slow film without excessive loss of depth of field through use of wide apertures, then a slow film is best for really high quality results. In bright Mediterranean or Alpine summers, a slow film such as a 25 ASA Kodachrome can be ideal.

Pictures of flowers for gardening catalogues, landscapes for travel brochures and architectural shots are generally taken on slow film. Sometimes a tripod may be needed if apertures are to be narrow enough to give good depth of field, but in brilliant sunshine there will usually be enough light to give both narrow apertures and high shutter speed.

In fact, in bright sunshine, anything but a very slow film may not give you the degree of flexibility you want. In bright sunshine, a fast film will always have to be exposed with high shutter speeds and narrow apertures if it is not

Available light indoors *Fast film may enable you to get candid shots indoors where light levels are generally low*

to be overexposed. Indeed, it may not even be possible to stop down sufficiently to avoid overexposure. A narrow aperture ensures that everything is in focus whether you want it to be or not; you cannot keep the background out of focus to avoid distracting from your subject. Neither can you avoid freezing any motion if you have a high shutter speed. So in certain circumstances, the creative possibilities might be greater with a slow film than a fast.

It would be nice if there were a film which could combine all the advantages of both fast and slow films. Of course this is not possible and you have to commit yourself to either one or the other when you load the camera. Medium speed films combine some of the advantages of both slow and fast films with some of the disadvantages. They are not ideal compromises by any means and each film

should only be used in the appropriate circumstances.

Medium speed films are best for a wide range of photographs in all conditions. They will not work in extremely low light, but neither will they have the graininess of a fast film. Medium speed films, particularly black-and-white, are ideal for portraits. Even the most beautiful complexion has minor blemishes and a slow, fine grain film shows every single one. A medium speed film provides sufficient graininess to disguise these blemishes while retaining enough contrast and definition to record all the textural detail that is wanted.

Whatever result you want, though, you should choose your film to suit the photograph you are looking for. Whether you want the fine detail of a slow film, the value of a fast film in low light, or the versatility of a medium speed film, you should load your camera with the film that gives the best results in the conditions you are most likely to encounter during your photography.

Chapter 4
EXPOSURE PROBLEMS
Contrast

As a camera user you know something about *contrast*—that is, the contrast between tones in a scene. An outdoor scene in high summer has tones ranging from very bright to black. On a misty day in winter, however, the same objects may be barely distinguishable shades of grey.

You can also see when one of your pictures is hopelessly dull and grey because of lack of contrast. You may also get the occasional picture which is so contrasty that it can be labelled 'soot and whitewash'. A photograph on a misty day can easily become an overall grey with all the subtle tones of the subject lost. A contrasty scene can also come out with inky black shadows and bald white highlights. By understanding how contrast affects photographs, you can avoid these extremes.

If you send your colour films away for processing and printing you have to accept the image contrasts that the laboratory thinks are right. With black and white film which you develop and print yourself contrast is very much more under your control, if you know how to handle it.

Eyes work differently from film: they can see a very wide range of brightnesses, picking out details in the brightest highlights and the deepest shadows. We expect to see such details in photographs, but there are difficulties. Film is more restricted than the eyes as to the range of tones it can deal with, and some tones are always lost. And even if it were possible to make a perfect negative of the most contrasty subjects a paper print can only show a limited range of brightnesses —about 100 to 1 at most.

A colour slide film is a little

Harsh highlighting *A subject with very high contrast, very difficult to photograph successfully without losing shadow detail*

better in some respects. It can show a much higher range of brightnesses than a print—up to about 1000 to 1—but it still has its limitations. A subject such as a brightly lit beach, with sunlight reflected off wet sand and a dark foreground, has a brightness range of up to 8000 to 1 between the highlights and the shadows. A photograph can record only part of this range, but you normally ignore detail in the highlights and shadows in favour of the middle range.

Oddly enough, a colour slide that exactly matched the contrast of the scene would look dull and lifeless. We prefer to see the contrast between objects made more apparent than it is in reality. This worsens the problem of maintaining good shadow and highlight detail. A good slide always has greater contrast than the subject it shows, but in the process shadows and highlights lose contrast as the middle tones gain contrast. The increase in contrast is deliberate: it helps to keep the brilliance of the colours of the subject. Loss of detail in the lightest and darkest tones passes unnoticed as long as it is not excessive and provided the middle tones look right.

Soft and mellow *This is a scene with little contrast of its own, which often happens in autumn and winter shots especially on a cloudy day*

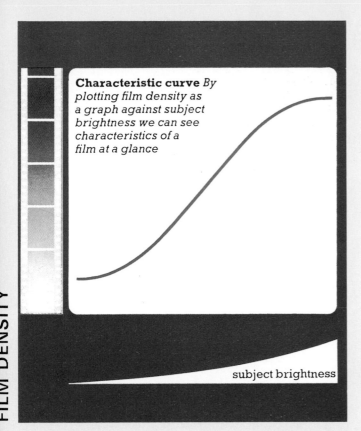

Characteristic curve *By plotting film density as a graph against subject brightness we can see characteristics of a film at a glance*

subject brightness

FILM DENSITY

Slope and contrast *The film contrast is shown by the slope of the graph. Steep slope means a film has high contrast*

subject brightness

FILM DENSITY

How to measure contrast

To understand and control the contrast of film and paper photographers use a simple graph. Since it shows the characteristics of the film for which it is drawn, it is called a *characteristic curve*. For all materials, films and papers, it has the same basic shape—a sloping straight line that flattens off at both ends. The steeper the slope, the higher the contrast. It is the straight part of the graph that is of most interest when talking about contrast.

The straight line shows that the greater the exposure, the more effect there is on the film. By plotting a characteristic curve of two different films, one of high and one of low contrast, it is easy to see the difference (fig. 2). The slope of the graph drawn for the high contrast film is much steeper than that of the film of lower contrast. Both curves start at the same point, but film A gets much denser than film B for the same increase in exposure.

Film speed and contrast

The contrast of a film is directly related to the film speed. Fast films have a low contrast. Very slow black and white film, for example, is suitable only for special applications, such as document copying, where extreme contrast is demanded. In the middle of the film speed range—from 50 to 400 ASA (ISO)—film manufacturers aim to produce a range of different films which give a choice of speeds while maintaining approximately the same level of contrast.

Film contrast is affected not only by the film speed, but also by development. As development increases, so does contrast. This can be used to tailor the film contrast to the tonal range of the subject. In the case of colour negative film, any attempts to alter the development run into trouble, as the whole development and printing procedure is arranged to give average contrast. If the range of tones falls outside the recording ability of the film, the resulting print will have bald white highlights and inky black shadows, with the colours probably distorted as well.

Contrast as a number

Because contrast is such an important characteristic of film, and it is inconvenient to have to draw graphs all the time, it is often described by referring to the slope of the characteristic curve. When twice as much exposure produces exactly twice as much effect on the film, the film has a contrast of 1, and with the correct choice of scales the characteristic curve has a slope of 45°. If the exposure has a greater effect, the result

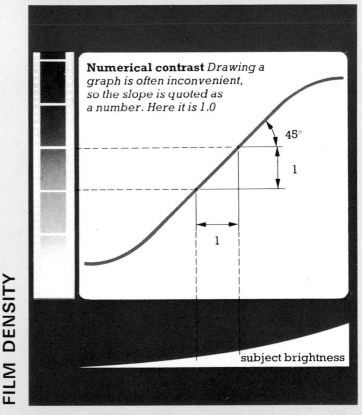

Numerical contrast *Drawing a graph is often inconvenient, so the slope is quoted as a number. Here it is 1.0*

45°

1

1

FILM DENSITY

subject brightness

is more contrast, and the numerical value of the contrast will be higher too. The numerical value of contrast is sometimes referred to by the Greek letter gamma. Most b & w films have a gamma of 0.5 to 0.8.

If a film has a contrast of 1, the tones of the subject will be recorded on the film with no increase in contrast. This is sometimes very important. When slides are being copied, for example, the copy should ideally be identical to the original. In practice this is rarely the case, and contrast is usually increased each time a picture is copied.

Lith film has the highest contrast of any photographic material. It is made especially for copying diagrams and other images where the only subject tones are pure black and white and it cannot be used for normal photography.

39

Shooting into the sun

The advice which came with the early box cameras used to be 'have the sun behind you' to make sure that the photograph came out with all the subject evenly lit. This advice might have been safe, but it did not always produce the most exciting pictures—and taking exciting pictures, with impact and drama, is what photography is all about.

Back lighting—in other words, light coming from behind the subject, towards the camera lens—probably produces the most dramatic lighting effects of all : sun pouring through leaves, shining haloes on hair and of course the inevitable sunsets. Any slight mistiness is emphasized by shooting against the light—think of shafts of light in a smoke-filled room, for example, which are much more obvious when looking into the light. This results from the light being scattered by small particles.

Shots against the light, whether or not the sun or light source is included in the picture, are often called by their French term of *contre jour*—literally, 'against the daylight'.

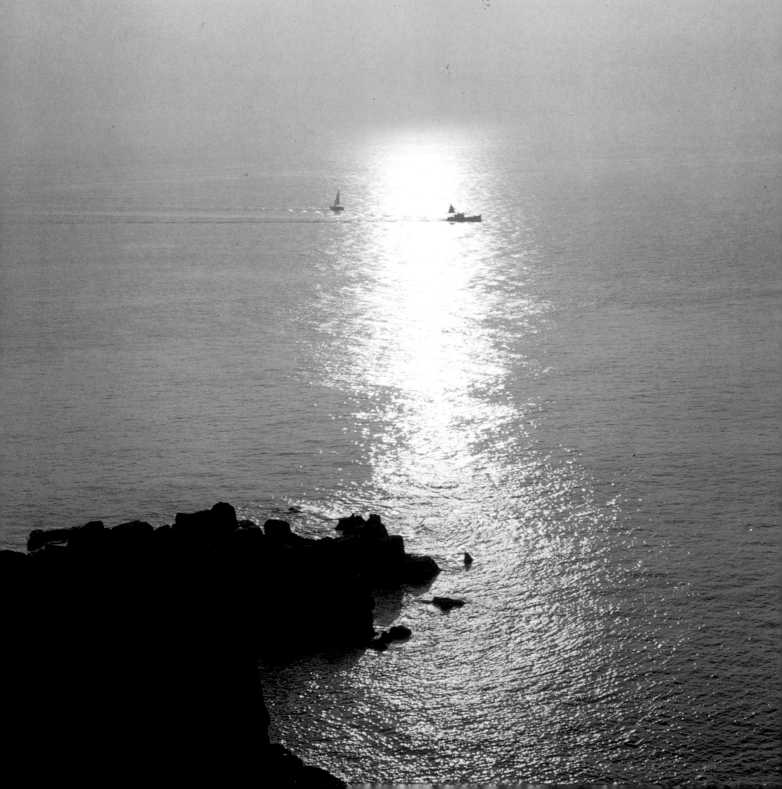

Sun behind the camera *A meter reading can be taken easily, but the result lacks depth and is generally uninspiring*

Rim lighting *Shooting against the light produces a rim-lit effect that adds atmosphere to a sylvan scene*

When photographing against the light, the two most common types of problem — technical and visual — become more difficult to separate than usual. This is because by changing the exposure, you can create pictures which will look quite different from what the eye sees. Training yourself to look for and recognize such opportunities is a basic part of your photographic skill. For example, a shot directly into the sun can produce either a dramatic flare, or a striking silhouette, depending on the exposure.

At this point, having recognized the visual potential, the problem is to decide on the exposure which will produce the picture you have in mind. Otherwise the shot may turn out washed out, or gloomy, at either extreme.

Getting the exposure right

How you decide on the exposure depends partly on the equipment you use. Most modern 35 mm SLR cameras have an exposure meter which measures the light from the scene as you see it in the viewfinder — this is *TTL* (through the lens) metering. A number of 35 mm cameras, however, have built-in meters which measure the light separately. Most non-reflex cameras (such as the Olympus Trip) operate in this way. Some people prefer to use a separate, hand-held exposure meter, while others may have no meter at all and simply guess the exposure from experience, or use symbols on the camera. In this case, your own judgement of how much light there is will take the place of light meter readings.

The chosen exposure for an against-the-light shot is generally a compromise. When you look at a scene, your eye and brain combine to make constant adjustments between dark and light areas so you can see detail in both. Film, however, records a more limited brightness range.

In subjects with a wide contrast between highlights and shadows, it can show detail in only one or the other.

Meters usually work on the basis that the dark and light areas in a scene will balance each other out, and give an exposure which, on average, is grey. So if you want a predominantly bright or dark shot, you may have to override the meter. If you have an automatic camera, with no manual override, read the 'How to fool automatic cameras' box.

Each scene is different in its exposure requirements, so it is impossible to give rules. The lighting may vary from a shaft of sunlight in an otherwise dark room, to a brilliantly lit open shore or

mountain background. There are, however, several guidelines which you can adapt to the different conditions you encounter.

Sunsets

Perhaps the most inviting back-lit shots of all are sunsets (or sunrises). They can be spectacularly vivid and colourful, and the foreground details are usually unimportant. A low sun can provide a bright background for silhouettes, transforming even a mundane scene into an effective picture.

While the setting sun may appear bright, it is dim compared with when it is high in the sky. Shadows are very weak,

Lens flare

How your shots into the sun turn out may depend as much on your lens as on the exposure. Modern photographic lenses have several elements—separate internal lenses—which together correct for all the

faults of simpler lenses. Zoom lenses may have 15 or more elements. Despite the latest anti-reflection coatings, light inevitably reflects between the elements, often forming ghost images of very bright lights. Sometimes these are spectacular and welcome; quite often, however, they destroy the shot.

Stray light inside the lens may not even form ghosts, but instead veils the whole image, lightening the shadows. Again, this is usually unwelcome. Dust on the front surface of the lens has a similar effect. If your lens is normally protected by a filter, which has collected the dust which would otherwise have fallen on the lens, it may be worthwhile removing the filter altogether for a shot into the sun.

With an SLR, you can see these effects before taking the shot. But with viewfinder cameras you must take pot luck. The lenses of such cameras often have fewer elements than SLR lenses, so the problem may not arise to the same extent.

Lens hoods, or even a strategically placed hand, can overcome some of these problems where the sun is not in the picture. But look in the viewfinder — attempts at shielding the lens with your hand run the risk of including it in the picture.

WORKING WITH FLASH
Electronic flash

Flashgun components *Despite their complex construction, manual flashguns are quite simple. These parts are numbered in the picture: 1 back of flashtube; 2 oscillator and rectifier circuit, with spaces on printed circuit board for automatic flash components; 3 main capacitor; 4 battery compartment; 5 ready light*

Most natural sources of light are easy to understand. Everyone knows that hot, burning objects glow brightly. and it is easy to think of the sun as a large ball of fire. Even light bulbs are quite straightforward—basically a white-hot glowing wire.

Lightning is different, and it has a lot in common with electronic flash. Both sources of light last only for a fraction of a second, both freeze moving objects that they illuminate, both give off a very bright light, and both lightning and flash are produced by a sudden discharge of electrical energy.

Unlike lightning—or any other form of natural light—electronic flash is under the control of the photographer. This, of course, is what makes it so useful. The way that the flash is generated is quite simple. It relies on the behaviour of certain rare gases, which only conduct electricity under certain conditions—and when they do, the electrical current flows in a very rapid surge, being converted to a bright light-flash for a fraction of a second.

The heart of a flashgun is a toughened glass tube containing the gas *xenon*. The shape of the tube varies. In most small flashguns it is short and straight, though in large studio flash units it is a spiral-shaped coil.

Tungsten electrodes are fused into the ends of the tube, and wires join them to an *electrical capacitor*. This is a device which stores electrical charge, and the difference in voltage between the two terminals of the capacitor (and, therefore, also of the flash tube) may be as high as 500 volts. No current flows through the flash tube because, in its normal state, xenon does not conduct electricity.

Before it can conduct, the atoms of xenon must be ionized—given an electrical charge. This is done by a wire wrapped around the flash tube. When a pulse of

high voltage current flows through this coil, the atoms of xenon are ionized, and the charge in the capacitor flows through the gas—producing the flash.

The pulse that flows through the wire around the tube is called a *trigger pulse,* and is produced by a trigger circuit. It is this circuit that is connected to the flash contacts of your camera, though the full trigger pulse does not flow through the camera. If it did, the high voltage would quickly burn out the contacts. Instead, a low voltage pulse flows when the shutter of the camera opens and this is then boosted by a transformer to a much higher level—thousands of volts.

Dangerous power
From this simplified description, one thing stands out. Even the simplest of flashguns, including the tiny units

that slip into the camera's accessory shoe, make use of extremely high voltages and on no account should you attempt to repair or dismantle one, however innocent and harmless it might look. The capacitors in a flashgun retain a charge long after the unit has been switched off, and the stored power is sufficient to throw you across the room should you touch the wrong part. This is why only a small pulse of voltage is passed through the camera.

Sources of power
Although flashguns operate at very high voltages, the power supply is usually of quite low voltage. A typical power supply is four 1.5 volt pencells, producing a total of six volts. To operate the flashgun this must be stepped up several hundred times.

It is not possible simply to step up the power from the batteries directly through a transformer, because transformers only work with alternating current (AC), and batteries produce direct

current (DC). Consequently, the power from the batteries must be fed into an *oscillator* —an electrical device that changes the DC of the batteries into AC. The AC output can then be passed through a transformer to increase the voltage. The oscillator is the part of the flashgun that makes the familiar high pitched whine that you hear as the flashgun recycles between flashes.

A further problem arises at this stage because, unlike transformers, capacitors work on direct current. The AC output from the transformer must therefore be changed back to DC in order to charge the capacitor. This is done with a *rectifier*, which acts like a valve and only allows current flowing in one direction to pass through it.

Ready lights
When the capacitor reaches a certain level of charge— usually about 70 per cent—a neon light is illuminated on the back of the flashgun to indicate that the flash is ready to be fired. Most flashguns will fire before the light comes on, but underexposure will usually result. If maximum power is required, it is best to wait until the capacitor reaches full charge. This point can be recognized by listening to the whine of the oscillator. When the capacitor is fully charged, the oscillator cuts out, often with an audible click. Wait for this sound if you need maximum power from the flashgun.

Computer flash
The majority of modern flashguns are automatic or 'computerized'. A light sensor on the front of the flashgun collects the light reflected back from the subject, usually from a small central section of it. When the reflected light reaches a sufficiently high level, the flash is quenched. In the case of ordinary computer flashguns, the remaining power is directed into a quench tube. This is just like the main flash tube, but it is concealed within the case of the unit and painted black.

The most modern computer guns employ an electrical component called a *thyristor*. This device interrupts the flash circuit as soon as the exact amount of charge required for the flash has been released. Any excess charge is not wasted, but instead remains in the capacitor, ready for the next flash exposure.

There are flashguns designed for use exclusively with some types of cameras. These are called *dedicated* flashguns. When such a flashgun is fitted to the camera's hot shoe, shutter speed is automatically set to 1/60 sec. The flash's ready light also appears in the camera's viewfinder, making it unnecessary

Freezing motion *Automatic flashguns can freeze motion at short distances. Manual flashguns are less efficient at freezing fast moving subjects (left)*

Water drop *This was frozen by a flash with a duration of only 1/7,000 sec.* **Owl in flight** *Electronic flash produces a far shorter exposure than a mechanical shutter, so it is widely used in nature and scientific photography. This enables the photographer to freeze the movement of fast moving birds and animals and to use high shutter speeds*

for the photographer to look away from the subject in order to check the flashgun.

Flash power
The power of the flash from a small flashgun would be very low if the flash tube was left completely exposed, so all guns use an efficient reflector to direct the light forward. In effect, this increases the illumination.

The power output of large professional studio flashes is measured in *watt seconds* or *joules.* Many large studio units generate as much as 15,000 joules of power. Compare this with the output of small portable flashguns— the average hot shoe flashgun gives a flash of 25 joules.

Guide numbers for flashguns bear no direct relation to the actual power output of the gun, and give only an estimate of the correct exposure in the average room

(see page 52). They cannot be relied upon for exact exposure.

When professional photographers use flash in a studio, they often take a flash meter reading, followed by a Polaroid test shot, and then take four or five pictures on film, just to make sure that one of them is correctly exposed. While few amateurs would go to such lengths to get a picture, it serves as a reminder that even the most sophisticated modern flash units are still not as reliable as the light from the sun!

WARNING
The flashgun shown here was dismantled by a skilled technician. It can be very dangerous to open the casing of even small units, because they store high voltage

Flash on the camera

Modern flashguns are the answer to the prayers of a good many photographers. Shooting indoors always used to be a problem. You either had to work in the artificial atmosphere of a studio or carry a lot of bulky and often fragile equipment round if you wanted to work on location, or trust the available light. The modern convenient, sophisticated small electronic flashgun overcomes those problems for all but the largest subjects. In addition, the light given out is very similar in colour to daylight so you do not need to use special film or filters.

Most people tend to use flashguns indoors to light portraits, often in a rather indiscriminate fashion, working on the basis that any record is better than none at all. However, it only takes a little experimentation and effort to improve these results, perhaps extending your technique into other, more adventurous, areas. And it is also worth using flash to make interesting records of subjects such as wedding presents, before and after shots of redecorating schemes, or your baby's first steps—just as likely to take place in a dimly lit living room as outside on the lawn.

How they work

Unlike flashbulbs and cubes, electronic flash guns are completely reusable. The flash is produced by passing an electric current through a tube filled with an inert gas. For those smaller models that fit easily on to the camera, the electrical power is supplied by a set of small dry batteries fitted into a compartment in the unit. Larger models use separate re-

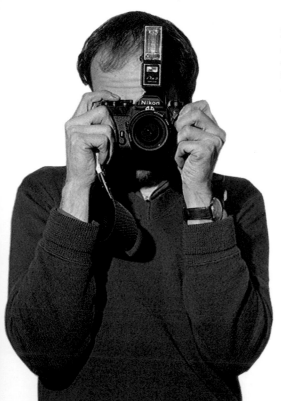

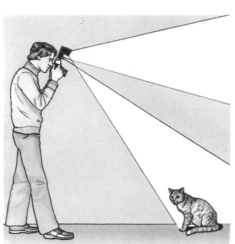

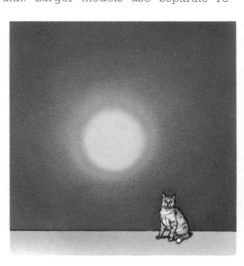

A group of people *A flashgun mounted directly on the camera is useful for taking off-the-cuff shots like this*

Fooling the sensor *An automatic gun has a sensor to control the light output. Since its beam is smaller than that of the flash, you can have problems if the subject is not framed centrally*

chargeable nickel–cadmium batteries. These are more expensive but much more economical.

Synchronization

No matter how powerful the gun, however, the subject will not be properly illuminated unless the flash is discharged exactly at the moment when the shutter is open. Such synchronization is ensured in two ways. Some cameras are fitted with *hot shoes*, usually on top of the camera. These are slide-in brackets into which a foot on the base of the gun is pushed. When this is done an electrical connection is established between the two that fires the flash as the shutter reaches its open position.

Not all SLRs have hot shoes but nearly all new ones have connection points for synchronization leads. These sockets are usually located on the camera body close to the lens mount but this is not invariable. The lead is plugged into both gun and camera, and the gun then fires whenever the shutter is pressed.

Older cameras may still have an M and X setting. The M setting was for synchronizing bulbs, which have a slightly different firing time. If you have such a facility on your camera always keep it set at X, which is the setting for electronic flash. At the M setting using electronic flash, you will get no pictures.

Automatic guns

Modern flashguns can be divided into two types, manual and automatic. Auto flash guns all have a manual option which you can use when necessary.

Automatic guns have a photoelectric sensor—a 'magic eye'—on the front of the unit. Its job is to measure the amount of light reflected back from the subject when the flash goes off. As soon as the programmed amount of light has been received back, it cuts off the flash,

A touch of glamour *If you are careful when using the flash mounted on the camera, you can use it for a range of subjects. A diffuser was used here*

Small children *With young children you have to be ready for spontaneous shots. Using the flashgun fitted to the camera can help you to act quickly*

giving the correct exposure.

It sounds as if this system should guarantee perfect results every time, but unfortunately this is not always true, and there are occasions when a light or dark background can fool the sensor.

The sensor will also be misled if you are taking a shot of a highly reflective subject or one which has a mirror or a piece of glass behind it. The light is then bounced straight back at the sensor causing extreme underexposure.

In addition, the sensor measures an angle of only about 12° to 20° of the total subject area so if your subject is out of its path, the sensor will read off the background. In this case the gun will have to be used manually.

Chapter 6
LENSES
Focal length

For a distant object the dimensions of the image are proportional to focal length. A lens with long focal length gives a bigger image than a lens with short focal length.

A 500 mm lens gives an image of a distant church spire which is ten times higher than that produced by the standard 50 mm lens. Since the width of the image is also increased tenfold, then the total area of the image projected by the 500 mm lens is 100 times that produced by the 50 mm.

Angle of view

As focal length increases and the image grows bigger, less and less of the subject is included in the picture and the angle of view becomes smaller also.

It may be impossible to move a camera far enough away from a subject to include all of it with the standard 50 or 55 mm lens. Replacing the standard lens by a *wide angle* lens reduces the size of image and includes more of the subject on the film. A wide angle lens is really just a short focal length lens, because as focal length decreases the angle of view gets wider.

A point to bear in mind since it often causes confusion is that the effect of focal length on angle of view varies with the film format. So while a 90 mm lens is long with 35 mm cameras, it is standard with medium format cameras. Some typical angles of view for lenses for 35 mm cameras are shown opposite.

Dock scene *A 90 mm lens designed for use with the large format camera which took this picture has enough covering power. The 90 mm lens for the lower shot was made for use with 35 mm film. The image is the same size, but only the middle is sharp and bright enough to use*

The focal length of a lens is of vital importance because it influences the subject–image relationship in two principal ways. First, focal length governs the size of the image that an object forms on the film in the camera. Secondly, it governs the proportion of the subject that the camera 'sees'—that is, the angle of view.

Image size

If a series of 35 mm cameras with lenses of different focal lengths are lined up side by side, all pointing at the same distant subject, the size of the images on the screens will be different on each camera in the row.

Lenses and perspective

If a camera is set up and pointed at any subject (such as a building with a figure in the foreground), pictures taken from the same point with lenses of different focal lengths will have different angles of view, and different amounts of the subject will be included in the pictures. There will be no differences in perspective as long as the camera is not moved.

28 mm. Close viewpoint
Standing near to the subject and using a 28 mm lens results in pictures which seem to be distorted

50 mm. Stepping back *Moving away from the mother and child resulted in normal perspective. A standard lens was used to fill the frame*

100 mm. Long shot *From a distance perspective seems flatter, but this was caused by the camera position not by the 105 mm lens used*

Standard lenses

The normal or standard lens for a 35 mm camera is one with a focal length of around 50 mm. This focal length gives a field of view roughly the same as that over which the eyes give satisfactory sharpness. You cannot, however, really compare a camera with the eyes because the angle through which the eyes give excellent sharpness is only a small proportion of the area we can actually see. Second, we can move eyes to scan a subject and also turn our heads. There is no magic in having a standard lens of 50 mm or so on a 35 mm camera. Many photographers claim that the wider angle of view of a 35 mm lens is preferable, while others maintain that a focal length of about 75 mm is better for general use because it enables the picture space to be filled more easily with the subject.

Telephoto lenses

A telephoto lens is essentially a lens with a long focal length, but it has a special construction that keeps the lens-to-film distance to a minimum. A basic long focal length lens must be placed one focal length away from the film if it is to form an image of a subject at infinity. In the case of a telephoto lens, the lens-to-film distance is considerably reduced so the lens can be made more compact.

With a 200 mm telephoto lens the rear surface may be only 100 mm from the film when the lens is set at infinity. A long focal length lens designed for use on a large format technical or view camera is normally of conventional construction, but small format cameras normally use telephotos.

Retrofocus lenses

A short focus wide angle lens presents problems when used on a single lens reflex camera—as before, to focus on infinity, any lens must be one focal length from the film. If the lens has a focal length of 24 mm, it must be exactly this distance from the film when photographing a distance object. For a single lens reflex camera to operate normally, however, there must be sufficient space for a mirror to be fitted in between the rear of the lens, and the film. 24 mm is not enough of a gap.

This difficulty is overcome by using an inverted telephoto or *retrofocus* construction which makes the lens-to-film distance much longer than the focal length, even when the camera is focused at infinity. In the case of a typical 24 mm wide angle lens, the lens-to-film distance may be as much as 35 mm measured from the rear surface of the lens. Some standard 50 and 55 mm lenses are of retrofocus type, as are many of the lenses in the Nikon range.

Covering power

If any lens designed for use on a 35 mm camera is mounted on a 4 × 5 inch technical camera and focused on a distant scene, the focusing screen of the camera will show a circular image, about 50 mm in diameter, the edge of which fades off into darkness. This circular image will just cover the 24 × 36 mm frame with an image which is evenly illuminated and sharp overall. Such a lens has a *covering power* adequate for a 35 mm camera but for nothing bigger than this format.

A lens with a focal length of 90 mm would be a telephoto lens on a 35 mm Leica, a standard lens on a 6 × 6 cm Mamiyaflex and a wide angle lens on a 4 × 5 inch Sinar technical camera. A 90 mm lens for a Leica needs only modest covering power relative to its focal length. The same focal length for a 6 × 6 cm camera would need normal covering power, but a 90 mm lens as a wide angle lens for the 4 × 5 inch format would have to be designed to give a much bigger image. The same 90 mm lens would not serve all three purposes equally well, so each camera format needs a separate lens to give best results.

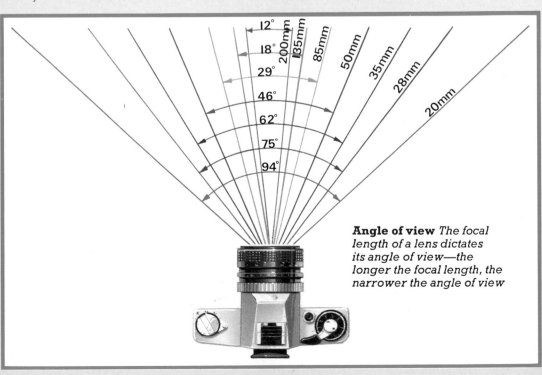

Angle of view *The focal length of a lens dictates its angle of view—the longer the focal length, the narrower the angle of view*

12° 200mm 135mm 85mm 50mm 35mm 28mm 20mm
18°
29°
46°
62°
75°
94°

Telephoto lenses

Versatile, easy to handle and with extra 'reach' for long distance shots, the medium telephoto (with a focal length between 85 and 200 mm) is an immensely useful lens. For many photographers it is the first major addition to their range of equipment. But to get the best from such a lens, you must learn to use it selectively and adjust your technique to suit its particular characteristics.

The medium telephoto lens differs from the standard lens in a number of ways. Most obviously, it provides a larger image, magnifying distant subjects and making them appear closer. While it is possible to photograph equally distant subjects with a standard lens and then enlarge them to a similar size at the printing stage, the quality is

not usually so good. In many situations where you cannot get very close to your subject, then, it is worth using a medium telephoto. A long telephoto gives an even larger image, but can create serious handling problems.

Where the subject is moving about, accurate framing can be difficult and for sports photography, many photographers find a 200 mm lens the ideal compromise—anything much shorter usually has insufficient reach. At a football match, for instance, you definitely need some form of telephoto for action shots if the players are not to be lost in a vast expanse of green. But to avoid missing the precise moment when the ball leaves the player's foot on the way to goal, you have to follow the action in

the viewfinder, moving the camera with the flow of play. With a long telephoto, this is more difficult.

Nevertheless, the medium telephoto can be invaluable for bringing even static subjects closer. Some photographers like to use a medium telephoto for candid photography because they can shoot from a distance and remain unobserved by their subject. Unfortunately candids on a telephoto tend to look rather distant, as indeed they are.

For wildlife photography, however, a medium telephoto may prove useful.

Village girls *The elaborate head-dress and delicate features of two Pakistani girls were captured by a 135 mm lens*

Focal lengths
Estimate the angle of view of a lens by holding an empty slide mount at the same distance from your eye as its focal length
Camera grip
Cradle the lens in your palm

Again a long telephoto provides larger images and for the ornithologist particularly this may be valuable, but for larger creatures than birds, a medium telephoto may be better. Indeed, on safari where you are frequently shooting from a moving vehicle, or following a moving animal, a medium telephoto may be the most useful lens to have on your camera—especially as it will often allow faster shutter speeds to be employed than a very long lens.

Because of their magnifying effect, there is a tendency to treat any telephoto lens simply as a telescope for the camera and to use it only for distant subjects. But this is not the only use for a really long lens and limiting a medium telephoto in this way is wasting its potential for particular effects with nearby subjects.

Since the telephoto produces a larger image, it is also useful for filling the frame properly. Even for a relatively close subject, the standard lens may include large areas of unnecessary, and maybe distracting, background scenery.

A shot of the bride stepping into the car, for instance, may be more effective if you can use a medium telephoto to close in on the face—even if you are standing less than ten metres away. Many press photographers use this technique to get good strong head-and-shoulders pictures of famous people in situations where they cannot stand quite close enough to get the desired framing with a standard lens. A lens much longer than 200 mm would probably include too little of the subject and is awkward to handle—a 135 mm lens is perhaps ideal for this particular situation. But any

Bison *With deliberate underexposure, a 200 mm lens gives a dramatic silhouette against a cloudy sky*

medium telephoto can help ensure tight framing for a wide variety of shots.

Associated with its larger image, the telephoto lens has a narrower angle of view than the standard lens. While the standard lens takes in about 45° of the scene before the camera, a 100 mm lens sees only 25° and a 135 mm lens sees just 20°.

This narrow angle of view can be very useful in certain situations. If you are shooting in a crowded street, for instance, it can be difficult to exclude unwanted objects from the frame. By using a medium telephoto, you may be able to aim the camera between the lamppost and the parked car and obtain a clear

view of the photogenic old lady chatting in the street.

Another situation in which the narrow angle of view of the medium telephoto can be valuable is when shooting towards the sun. With a wide angle or even a standard lens it may be difficult to exclude the sun from the frame and still keep your subject central. This can cause tremendous exposure problems (see page 40). By using a telephoto, you may have a sufficiently narrow field of view to include only your subject and not the sun.

You can only assess precisely what the telephoto's angle of view is with the lens actually in position on the camera, but to avoid changing lenses unnecessarily you can make a rough estimate with a slide mount. Close one eye and hold a slide mount in front of the other eye. When the slide mount is 85 mm from your eye, the view through the mount will be the same as that given by an 85 mm lens. The same applies to other distances and lens focal lengths.

One effect of telephoto lenses, which is not always appreciated, is the apparent flattening of perspective. A wall seen

55 mm *Portraits taken with a standard lens can accentuate noses and chins. Medium telephotos give better results*

85 mm *The facial perspective given by this focal length is much more natural. This is an ideal lens for portraits*

200 mm *It is possible to make good portraits with this focal length, but sometimes facial features look too flat*

from close to, for example, has a *steep* perspective so that the near end appears much larger than the far end. At a distance, however, perspective is much flatter so that the near end of the wall only seems a little higher than the far end. What the telephoto does is close in on the subject, giving the same framing as a nearby viewpoint with a standard lens but the same perspective as a distant viewpoint. Perspective is not actually changed by the telephoto but perspective in photographs taken on a telephoto appears to be unnaturally flat.

This foreshortening effect is something to be wary of when using a telephoto. It can make photographs look very crowded. In a photograph taken looking down a row of buildings, they seem to be crowded close together.

This can be a useful creative device, but unless you want this particular effect it can be a nuisance. If you are photographing a person at some distance, for example, the background may seem to loom unpleasantly close whether it is in focus or not. Backgrounds that you thought were too far behind your subject to matter may be brought unpleasantly close by telephoto.

Of course, there are times when you may actually want this crowding effect. A telephoto is a popular way of showing traffic congestion because vehicles seem almost to jostle one another. The telephoto's ability to foreshorten may be a positive advantage in other situations. It is this feature more than anything that makes the medium telephoto so popular for portrait photography.

With a standard or wide angle lens, moving in close enough to the subject to fill the frame with head and shoulders can produce some unpleasant perspective effects. Any parts of the face very close to the lens appear unnaturally

Old soldier *An expressive detail picked out by a 135 mm lens can make as strong a picture as a full length shot*

large—many sitters have been given huge bulbous noses by close-up shots with a standard lens. With a medium telephoto, you stand much further back from the subject and the less extreme perspective gives a more natural look. If you wish to produce a flattering portrait of someone with unusually large features, a telephoto may be a simple and unobtrusive way of toning down the large features.

By allowing the photographer to stand back from his subject the medium telephoto also helps to make a portrait session less awkward. With a standard lens, the photographer has to move in intimidatingly close.

A lens of around 90 mm is perhaps the best lens for portraits. Lenses of this size have maximum apertures only slightly smaller than a standard lens and are light and compact. Lens sizes of 100 and 105 mm are also popular for portraits although the perspective is perhaps a little flat and the lenses usually

have a slightly smaller maximum aperture. With anything much longer than 135 mm, however, the effect on perspective is sometimes excessive and facial features may look compressed.

If you do use a telephoto for portraits, you will appreciate that they give shallower depth of field than a standard lens, and you should focus on the nearer eye for three-quarters portraits.

The shallow depth of field can be both an advantage and a disadvantage. Telephotos appear to be easier to focus than standard lenses if you have an SLR. Because the depth of field is normally visibly less at any given aperture, the subject is either positively in focus or positively out of focus on the camera's focusing screen.

Shallow depth of field can also make it easier to deliberately throw a distracting background out of focus. Using a medium telephoto, you can often blur the background for a portrait without even opening up to maximum aperture.

In low light conditions or when you have a slow film in the camera, however, the depth of field available with even a medium telephoto can be too small. You may find it impossible to get all the subject in focus. In this case you must choose carefully what to focus on.

One way of increasing the depth of field is to use a narrow aperture in combination with a slow shutter. But slow shutter speeds should not usually be used with a medium telephoto unless you have some means of steadying the camera. Because the image with a telephoto is that much larger, any movement of the camera while the shutter is open is exaggerated and may show up in the photograph. The extra weight of a larger lens also makes it harder to hold the camera steady. With a medium telephoto lens, you should not use the camera hand-held with shutter speeds longer than 1/125 second. Lenses with a focal length of 135 mm or longer really need a shutter speed of at least 1/250 second.

Unfortunately, although maximum apertures are greater than with a long telephoto, the maximum aperture on a medium telephoto is usually less than a standard lens, and on the cheaper versions the loss can be three or four stops even at 135 mm; on a 200 mm lens it may be even more. So, under conditions which would require an exposure of 1/1000 second at $f/1.4$ on the standard lens, a 200 mm lens would need a relatively slow shutter speed for correct exposure. With an $f/4$ lens this would be 1/125 second, which is really too slow for a hand-held shot. It is, therefore, well worth finding some means of keeping the camera steady if you are using a medium telephoto—particularly with close-up subjects.

A tripod is definitely the best means of holding the camera firmly and many

Window with ivy *Soft lighting heightens the calm atmosphere of this composition created with a 105 mm lens*

medium telephotos have built-in tripod adaptors, but a tripod may be awkward to handle and to carry around—though you may be able to manage with a monopod or some improvised types of camera support. In fact many sports photographers prefer a monopod because it allows them to follow the action that much more easily. Perhaps the best compromise is to use a tripod in the studio, and to use a monopod, or improvise, when on location in poor light conditions.

Whether you are shooting from a tripod or the hand, however, you must allow a greater margin of error in framing with a telephoto than you would with your standard lens. This is again because the narrow angle of view means that framing errors are exaggerated.

One further, but often forgotten, problem that you may encounter when using longer medium telephotos is atmospheric interference. Because the image is that much larger, mist or particles of dust that you hardly notice with the naked eye may become obtrusive in a photograph shot through a medium telephoto. In fact many long distance shots are vague and misty with poor contrast. The loss of definition can often be severe, and on misty days, it is rarely worth using a 200 mm lens for long shots. In addition, on hot days the shimmering of the atmosphere over even a moderate distance can produce unsharp results, particularly when using focal lengths approaching 200 mm. Rippling which you do not notice in the viewfinder can blur the image.

Nevertheless, providing you frame up and focus carefully and keep the camera steady, a medium telephoto can be a useful lens in a wide variety of circumstances.

Lake scene *By closing in on a part of the scene, a long medium telephoto can give a greater sense of place, involving the spectator*

Wide-angle lenses

positioning the camera in relation to the subject.

As well as having a wider field of view, wide angle lenses are also noted for the great apparent depth of field which is created at all apertures. The shorter the focal length of the lens, the greater the depth of field. So even though the maximum apertures of wide angle lenses are almost as large as those of standard lenses, you still get a wide depth of field and focusing is therefore less critical. This quality allows you to take characteristic wide angle shots with a subject and its background both sharp.

Short focal length lenses like these do not, as is often believed, actually change perspective. The close viewpoints allowed by such lenses can cause perspective effects which look distorted but

Great depth of field *is characteristic of a wide angle lens, helping make both foreground and background sharp.*

Interior shots *are also easy with these lenses, especially if space is confined and you cannot move backwards*

A wide angle lens is designed to take in a large view and is indispensable when working in confined spaces or when you want to cover a large area. These lenses also have their own qualities, causing apparent distortion and foreshortening so that objects closest to the lens appear large while the background diminishes in size dramatically.

Although a 35 mm focal length lens used to be considered a standard short focal length lens, the wide angle group now includes anything from about 24 mm to 35 mm. Any lenses with a focal length less than 24 mm are considered to be ultra wide, or even fisheyes, and these have their own special properties.

Many people choose a 28 mm lens as their preference for this type, partly because these lenses are reasonably priced, but also because they allow the typical wide angle effects without easily giving apparently distorted images, such as bent walls. A 35 mm lens is very close to the standard 50 mm lens—so much so that many photographers choose one as an alternative standard lens. With lenses which have a wider field of view than that of a 28 mm, it is much easier to create unusual images with abrupt perspective and more care is required when

ordinary shots you can manage with a 50 mm lens by just walking farther back, but this is usually impossible to do in confined spaces. Similarly, a wide angle lens is ideal for photographing a large building, especially if you want to include the whole of the subject in your shot but wish to avoid the foreground distractions which may be inevitable if you have to stand well back and use a normal lens.

These applications can, however, all cause difficulties. The most common problem is that of foreshortening, which causes verticals to converge so that tall buildings appear to be leaning back. This happens because objects close to the camera appear larger and those in the distance appear smaller. By keeping the camera back vertical you can avoid this effect, but tilting it back to include the upper part of a tall building gives this convergence. The only easy solution is to stand back farther if the shape of the subject is still too exaggerated for your liking. The viewfinder indicates exactly the sort of results which you can expect.

Foreshortening can be effective, however, and you may be pleased with the effects you get, such as when standing close to the base of a tall building.

Convergence can be avoided by using a special type of lens whose operation is based on the flexibility found in a technical camera. Such a lens is known as a *perspective control* or *shift lens*. It works on the principle of keeping the camera film plane parallel to the subject and shifting the lens upwards off its axis. Such equipment is expensive and is only worth considering if you intend specializing in architectural shots.

Wide angle composition
In all types of wide angle photography you will find that even a small change in the position of the camera has a dramatic effect on the composition of your picture. Experiment by trying different heights and angles, but remember that foreground details will be large and backgrounds will recede into the distance rapidly if the viewpoint is a particularly close one.

Buildings *are ideal subjects for wide angle lenses. Even though the verticals converge, the whole area is covered.*
Festive table *Bystanders are unaware they are in view with a wide angle lens*

which are perfectly natural ways of viewing objects at close range. The perspective is the same for the human eye under such circumstances, although your eye corrects this apparent distortion for you. To appear realistic, all wide angle photographs should be assessed at slightly closer viewing distances. If you hold the print or transparency closer to your eye, you will find that perspective appears more natural.

The apparent distortion which can be created may be used to advantage and many people are attracted to using such a lens because of this. While the human eye is capable of a wide field of vision, a short focal length lens can do this holding all areas of view sharply in focus. This means that you can keep both the foreground flower and the church on the horizon in focus. You can also use the dramatic curves caused by distortion at the edges of the frame to focus attention on the undistorted subject in the centre.

Field of view
Like all other techniques the use of a wide angle can be overworked, so be selective about when you choose to fit this sort of lens. A 50 mm standard lens takes in a 46° field of view while a 35 mm lens takes in 63°. The field of view widens progressively after that so that a 28 mm lens takes in 75°, a 24 mm 84° and, moving into ultra wide angle lenses, a 20 mm takes in 94°. This wider coverage has a number of useful applications.

Wide angle lenses excel in confined spaces. When you want to include a large coverage in an interior shot, this type of lens is the only choice. For many

By taking in such a wide area you will have to think more carefully about the composition of your photograph as a whole. The main subject will usually be surrounded by a wide background area which must be selected so that it enhances the overall picture.

While the different possibilities available with a wide angle lens are as varied as those with any other type of lens, there are subjects and techniques which are particularly suitable.

For example, wide angle lenses are useful for candid photography since focusing is less critical and there is less chance that part of the subject will be excluded from the frame when taking a spontaneous shot. It is also possible to photograph people without them realizing it by appearing to shoot past them. Your subject is unlikely to realize that he has been included in your picture, let alone that he is actually the main subject of your photograph.

When taking this type of photograph, however, try to avoid including anything that is important to your picture in the corners of the frame. There is a strong tendency, especially with the wider lenses, for the corner details to be stretched so that their shapes are distorted. If this happens to someone's face, the effect can be particularly distracting. Photographing people with wide angle lenses can also give unflattering results if the shot is taken at close range. Facial features will be exaggerated so that the closest part of the face to the lens, usually the nose, will be out of proportion to the rest of the face. This problem is worse with very wide angle lenses, so these should not be used for close-ups unless you want a special effect.

When using wide angle lenses for landscapes, take care that the main part of the scene does not appear too far away so that all detail is lost from the image. Wide angle landscapes are particularly effective when a foreground subject is used so the frame is filled with a balance of foreground and background details.

These lenses are also particularly useful for composing the subject within a frame, whether it is a door, a window, two trees or whatever strikes you at the time. By using a small to medium lens

Vignetting *is easily caused if you use the wrong sort of filter or lens hood with a wide angle lens, especially at wider apertures*

Longhorn *A careful choice of viewpoint when using a wide angle lens can turn an ordinary scene into a dramatic shot. While a person's face would be distorted, the animal simply becomes more striking*

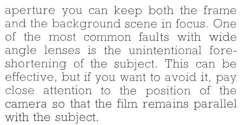

aperture you can keep both the frame and the background scene in focus. One of the most common faults with wide angle lenses is the unintentional foreshortening of the subject. This can be effective, but if you want to avoid it, pay close attention to the position of the camera so that the film remains parallel with the subject.

Precautions

With a wide field of view a lens hood is an important accessory. Strong lighting can easily end up causing flare when reflected internally between the lens elements, and unless you take proper precautions you can spoil your shot. Sometimes you will be able to see flare or ghosting in the viewfinder but, more often, it is not visible to the eye and will only show up on the film. Of course, such an effect, even if unintentional, can sometimes make a photograph.

Another precaution to take with wide angle lenses concerns filters and other accessories screwed into the threads in the front of the barrel. If you use more than one filter, or you use a particularly thick filter, you may end up with vignetting problems. These result in the edges of the image being cut off, particularly at wider apertures. This problem is common with lenses of 28 mm or wider and you should try to use only filters and hoods recommended by the manufacturer. Polarizing filters can be

very effective when used on wide angle lenses since it is likely that a wide expanse of sky will be included in outdoor shots. These filters tend to be thicker than ordinary ones, so be particularly careful to choose one which does not cause vignetting.

Exposure control and focusing also need care when using wide angle lenses. The wide area of composition of a wide angle photograph often includes a variety of light levels. If a large amount of sky or shadow is included, make sure that you compensate for this with your exposure. Take a reading directly from the main subject and then use this setting for the whole shot. If you are using an automatic camera, switch to 'manual' or use the memory control.

Focusing can also cause problems since it is harder to see whether images in the viewfinder are sharp or not. Although focusing is less critical, especially at small apertures, you still have to take care if you are to be sure of sharp results. If you have a camera with a split image focusing screen you will find the job easier.

Wide angle lenses can be of great help in extending your technique. Make sure however that you are particularly careful over composition and when arranging your main subject in the viewfinder remember that both the foreground and the background are going to form important parts of your picture.

Zoom lenses

The zoom is now the most popular additional lens for a 35 mm single lens reflex (SLR) camera. Until recently, people tended to buy a fixed telephoto lens—but now, zooms account for over half of lens sales.

The *idea* of zoom could hardly be more attractive. Buy just one lens, at possibly no more than the price of a single fixed lens, and you have at your command a whole range of lenses of widely varied focal lengths that is, giving different image sizes.

What is more, the 300 mm lens's focal length is continuously variable. By a quick adjustment of the ring on the lens barrel, you can magnify the subject in the viewfinder to the exact size required within the zoom's range.

And all this is possible without the inconvenience of carrying around several lenses, or of changing lenses during picture-taking. A zoom can free you, in fact, to concentrate on more important things—like the subject in front of your camera.

Clearly a zoom can expand your photographic horizons. But on close consideration, how often could you use the lens? Could your photography really be improved by the continuously variable focal length? Could you really exploit its advantages to the full? And how does one decide what to buy from the many ranges of focal length available?

Categories of zoom

For the 35 mm camera user, the choice of a zoom lens used to be restricted to one with a focal length adjustable from about 80 to 150 or 200 mm—generally described as a telephoto zoom. Today, this is no longer true.

Manufacturers are putting out increasing numbers of wide-angle zooms, with a typical range of 21 to 35 mm. And the medium-range, 'all-purpose' zoom, usually covering focal lengths from 35 to 80 mm, is also growing in popularity.

There is no set rule for the exact range of focal lengths offered in each category. Zooms of the telephoto type cover a particularly wide range. There are 50-135 mm, 90–200 mm, 70–230 mm, 75–150 mm, even 135–600 mm zooms and one

Rising to the occasion *Without a zoom this shot would have been missed : the fox disappeared too quickly for a change from a standard to long-focus lens*

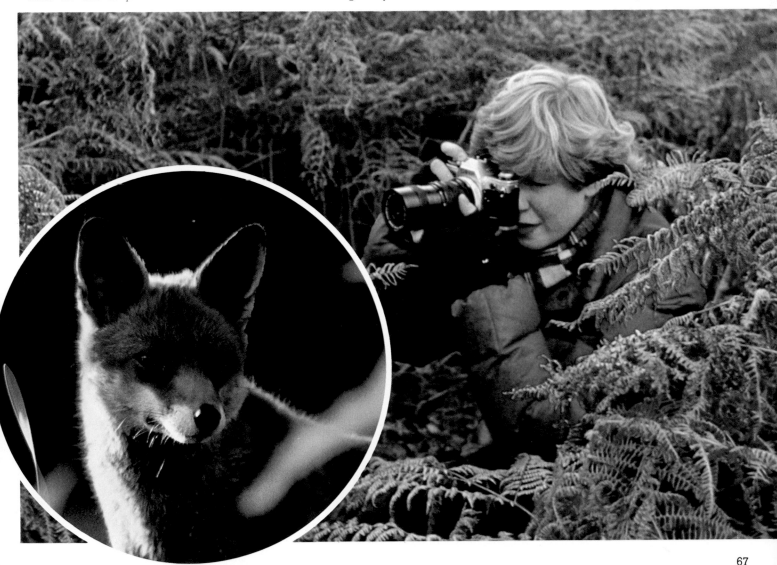

manufacturer offers a staggering 360–1200 mm model. But it is fair to say that the most popular telephoto zoom, usually considered the most versatile and manageable, remains the 80–200 mm. Indeed, this is now the most popular second lens for 35 mm SLR users.

Wide-angle zooms generally cover two zones of focal length: 24–35 mm and 28–50 mm. The medium range is more varied again, with combinations such as 35–70 mm, 40–80 mm, and 28–80 mm.

What the zoom can do

Most people would consider a zoom lens's greatest benefit to be that it allows you to fill the picture area over a considerable range of distances without having to change the camera position. At a football match, for example, you can follow the play from a single position, ranging from shots showing the distribution of the players over the field to moderate close-ups of incidents.

Another way to use a zoom lens, which applies particularly to the medium range types, is to help you compose your shots in the viewfinder. Most pictures need a small amount of trimming along all or some of their edges, either for added impact or for balancing the composition. If you have your own darkroom, you can do this 'cropping' as a matter of course under the enlarger. But many people prefer to have their prints or slides with no more fuss and bother, and want to get them right first time. With a zoom, you can make a quick, simple adjustment to obtain that all-important, last-minute alteration of the image size relative to the picture area.

A zoom also gives control over the apparent distance between objects. A short focal length lens (ie a wide angle) 'spaces out' everything in view, enlarging things close to the lens and reducing the relative size of objects in the distance. A long focal length (telephoto lens) does the opposite, closing up the spaces between objects in the dist-

ance so they seem to be closer together than they are. By looking through the viewfinder while you lengthen or shorten the focal length of a zoom, you can watch this widening and flattening.

Another major feature of the zoom lens is its constant focus. This means that you can focus precisely with the lens at its maximum telephoto setting, then zoom to a wider setting while the image remains critically sharp.

However, you should be aware that although the constant focus works perfectly on most good zoom lenses, there is sometimes a small change in focus that has to be corrected after zooming. Generally, the smaller the range of focal lengths offered by a zoom, the better it is likely to hold its focus. One type of zoom, known as the varifocus, needs to be refocused every time its focal length is adjusted.

Many modern zoom lenses claim to offer a macrofocusing facility. This allows focusing on subjects very near the lens to give a life-sized image in the viewfinder, and, of course, on the negative. Such a lens has a quite remarkable range of uses, and, in theory, will stand you in good stead for not only action work at long range, but also close-up, nature or specialist photography.

The drawbacks

When people think about the full advantages of zoom lenses, they often ask why conventional lenses are bought at all. This is a fair question, to which, however, there are some good answers.

The greatest drawback is the zoom's poor light intake for its size. A photographer accustomed to focusing on the bright image given by a standard lens working at, say, $f/1.7$, will be horrified at the low image brightness of a zoom whose maximum aperture is a mere f 3.5 or $f/4$. Not only is the image dimmer, but focusing is more difficult as the f-number increases. A few zooms, usually those with short focal lengths, do open up to $f/2.8$, but these are particularly bulky.

Added to this is the problem of increased light absorption. The amount of glass used in the complicated construction of a zoom absorbs and scatters light. It is a common experience for zoom users to find that when light is poor, the zoom makes picture taking impossible. Changing to a fixed lens, they find they can easily make a correct exposure at the same aperture; indeed, they may even be able to stop down.

Bulk is the second big snag. To achieve a successful zoom, the manufacturer has to use as many as 15, or even more, glass lens elements. This makes the zoom generally longer and heavier than an equivalent fixed focal length lens.

Most appreciate that in certain cases this is not a particular disadvantage because in any case the zoom is doing the job of two or possibly more lenses which would have to be carried about in its place. And it has to be said that some zooms have reached a remarkably compact standard of construction. But again

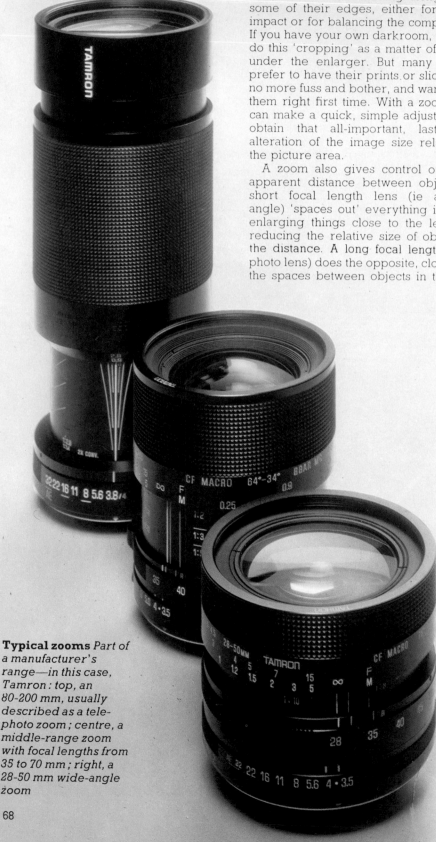

Typical zooms *Part of a manufacturer's range—in this case, Tamron: top, an 80–200 mm, usually described as a telephoto zoom; centre, a middle-range zoom with focal lengths from 35 to 70 mm; right, a 28–50 mm wide-angle zoom*

the most useful zoom lenses, with a wide range of focal lengths and comparatively wide maximum apertures, are also the heaviest. They will probably unbalance the camera, making it impossible to carry comfortably on the neck strap, and will certainly rule out the use of your ever-ready camera case. The wide-angle, or medium-range zoom, will not, under any circumstances, be as compact as a standard or wide-angle fixed focal length lens.

And at this point, the photographer has to make up his own mind about how vital compactness of the lens-camera unit is for his particular purposes.

You will hear conflicting reports about the image quality given by zoom lenses.

Zoom construction *The cutaway shows the considerable number of glass lens elements required. The central groups are usually the moving parts*

Wide-angle zoom
The two extremes of the 28-50 mm zoom show how different pictures of the same subject can be taken from the same viewpoint. This type of zoom comes into its own for pictures of buildings and in built-up places generally. The 50 mm setting gives, in effect, a standard lens

Tennis *A classic use of the telephoto zoom: the camera position is fixed, but the image size can be adjusted to fill the frame as swiftly as the players move*

But it is fair to say that zoom lens performance has not yet reached the level of other, fixed focal length lens types, and probably never will. On the other hand, it is improving all the time, and a zoom of reputable make will perform acceptably for all but the most demanding photographers—provided it is used within its limitations, that is, not at full aperture, and, when on a long focal length setting, with a fast enough shutter speed to 'freeze' the resulting exaggerated effects of camera shake.

Sharpness, of course, is only part of the story when it comes to lens performance. Such things as image contrast, distortion, vignetting (fall-off of light towards the edges) and lens flare are also important. In each case, the complexity of a zoom counts against it.

One other thing must be said against zoom lenses, which may not at first seem fair: they can encourage lazy photography.

Most will agree that one of the vital habits to acquire for good picture-taking is the urge to move about, looking for the best viewpoint, or that new and interesting angle for a shot.

A zoom encourages you to remain rooted to a single spot in other words, not to experiment. Many a picture is taken with a zoom at its extreme telephoto setting when a standard lens could have been used simply by moving

forward. The resulting picture is unsharp, because the telephoto effect has exaggerated camera shake.

You and a zoom lens

In photography, the considerations you make before buying a new piece of equipment almost always boil down to one, simple question: will it help me do my kind of photography better? The zoom lens is no exception.

Take, for instance, the long focal length, telephoto zooms. They come into their own when photographing active subjects so that you cannot move your viewpoint, but the subject is always doing so. Football, motor racing, sailing and many other activities come into this category. So also do young children as they toddle about the garden.

Both globetrotters and photojournalists find telephoto zooms invaluable for capturing candid shots. This is a classic use of the telephoto, and the zoom provides great flexibility when the photographer has no time to choose the ideal viewpoint or lens.

So if this sort of photography is close to your heart, and you do it often, a telephoto zoom lens is well worth buying. But there is one caution: because of its relatively narrow widest aperture, it is best for outside work in the open spaces, with good lighting conditions, rather than indoors or in poor light conditions—unless it is used with flash.

For the same reason, a telephoto zoom is not the best lens for portrait photography. This is partly because one often wishes to work indoors by available light, when good image quality and the widest possible aperture count above everything; and partly because in the formal studio situation with the camera on a stand, the variable focal length is not needed.

The wide angle zoom is an interesting lens. If you enjoy using a wide angle for artistic reasons, or if you frequently photograph the interiors of buildings, or,

Definition loss *We tested a 70-150 mm zoom at 135 mm on full aperture, f/3.5 (left). A fixed 135 mm lens (same make) performed noticeably better at f/3.5*

Mid-range zoom
Useful as a general-purpose lens. Standing on the cliff above the cove one has a choice of a medium wide-angle view at 35 mm, or, at 70 mm, a closer view of the children and broken wave

at the opposite extreme, do plenty of landscape photography, it will probably be a good buy.

It will enable you to wander about, filling the frame to perfection, whatever size of room you need to photograph. Equally, it will enable you to adapt to photographing different sizes and areas of a building from the outside without changing lenses.

And for pictorial purposes, it can be useful, not to say fascinating, to be able to manipulate 'on camera' the appearance of a landscape, and how much of it you include in the picture.

It is more difficult to say what a medium-range zoom can do for your photography. It certainly covers some very useful focal lengths. At some stage, most 35 mm camera users find them-

70

ZA MÍR - ZA SOCIALISMUS

Stewart Fraser/Colorsport

selves saying that 50 or 55 mm is just not a particularly useful focal length. It may give a field of view closest to that of the human eye, but relatively few subjects fit its angle of view with any ease. For landscapes, it tends to be either too wide or not nearly narrow enough; for portraiture, it has to be used too close to the sitter for comfort. People find themselves wanting just a little more, or less, focal length than the standard lens can give, and this is exactly what the midrange zoom provides. So in theory it is an extremely useful, all-purpose lens.

As long as the photographer is prepared to live with its built-in drawbacks, this is true in practice as well. It

will not give corner-to-corner sharpness on big enlargements from 35 mm film. It will not give much freedom to work in poor lighting conditions. And it may limit the useful range of shutter speeds. But under normal conditions it can provide great flexibility and can offer great creative opportunities.

The same applies to zoom lenses in general. To sum up—are they worth having? The answer is a cautious 'yes'—but be certain before you buy one that it will really be of use to your kind of photography. And if you have fixed focal length lenses as well, use them whenever possible—they will undoubtedly give better results.

Telephoto zoom
Often used for sports shots. This pair, taken from the same location at the extremes of an 80-200 mm zoom, shows how the widest setting gives an overall impression. The 200 mm shot allows more details to be seen

71

Simple close-ups

Any photograph looks better when the frame is filled by the subject, but when you are photographing objects only a short distance away, it is sometimes impossible to focus the camera close enough to do this. Most 35 mm SLRs focus down to about half a metre—close enough to fill the frame with this page. It is not difficult to make lenses that focus closer—macro lenses do just this—but as you get nearer to the subject special problems begin to crop up. Half a metre is about as close as you can get without using special close-up techniques, so it is a sensible point to fix as the minimum focusing distance for standard lenses.

Close-up equipment

If you already own a zoom lens, you may not need any special equipment to take close-up pictures. Many zooms have a macro focusing facility, which makes it possible to focus on much closer objects than standard lenses can cope with. Some of these lenses focus as close as 15 cm, but are used at a long focal length. In this way, they are able to form images as big as 1:3—that is, where the image on the film is a third of the size of the original object. The quality of the pictures is usually poor, however, and for serious close-up work, macro zoom lenses are not really adequate.

True macro lenses are quite different from macro zooms. They are specially constructed for close-up work and usually focus from infinity right down to 1:2 (half life size) with a single turn of the focusing ring. Another feature that distinguishes them from other lenses is the design of their optical components. The aberrations of macro lenses are balanced so that they give their best results at short distances. Most other lenses work better when the subject is three metres or more from the camera. Unfortunately, macro lenses are bulkier than ordinary lenses, have small maximum apertures, and are expensive.

A much cheaper way to take close-up pictures is to use extension tubes, or supplementary close-up lenses. Supplementary lenses screw into the front of the camera lens, just as a filter does. They change the effective focal length of the lens, which enables you to focus on objects nearer the camera.

Extension tubes are simply short metal rings which fit between the camera body and the lens. Because they move the camera lens out from the body, nearby objects are brought into sharp focus. Both extension tubes and close-up lenses are sold either individually or in sets.

Butterfly *To fill the frame with a small subject, you will need to move in very close. A set of extension tubes moves the lens far enough out to bring a tiny subject like this into focus*

Best of all for close-up work, however, are expanding bellows. They act like extension tubes but give a continuous and much greater range. Some bellows will give up to 20× magnification with a standard 50 mm lens. But all this comes at a price—they are really items for the professional.

Whatever equipment you use, close-up photography needs more care than that of distant subjects. Because the images on film are bigger, camera shake becomes more obvious, and it is essential to keep the camera very steady. Focusing is critical, because depth of field is greatly reduced—often to a matter of millimetres—and there is no margin for error. Exposure measurement is sometimes complicated by the fact that certain close-up methods require extra exposure according to the magnification of the image. The secret with close-ups is to plan each shot meticulously.

Supplementary lenses

Close-up supplementary lenses minimize these problems. This is partly because only moderately close subjects can be handled by this method, and pictures in extreme close-up—where the problems are greatest—are better left to other types of equipment. Because they are simple to use, however, a set of close-up lenses is a good introduction to close-up photography.

Close-up supplementary lenses look rather like clear glass filters, but with a slight curve. Their power—simply, the degree of effect they have in focusing the lens closer—is measured in dioptres. The dioptre power is equal to the reciprocal of the focal length of the close-up lens. A one dioptre lens has a focal length of one metre, a two dioptre 0.5 metre, a three dioptre 0.3 metre, and so on. The higher the power a lens has, the more effect it will have when it is attached to the camera lens. When lenses are used in combination, the powers are added together to get the new power.

If you focus your camera lens on infinity, and then fit a close-up supplementary lens, the new point of sharp focus is equal to the focal length of the

supplementary. If you are using a two dioptre lens, for example, the new focus point will lie half a metre from the camera. With the lower power lenses, turning the focusing ring brings the point of sharp focus closer to the camera, but high power supplementaries have such a strong effect that the focusing ring becomes virtually useless. In this case, the simplest way to focus is to move back and forth, nearer and farther away from the subject, until the image snaps into focus in the viewfinder. This technique is useful for all kinds of close-up work, since at short distances a small change in camera position produces a dramatic change in the plane of the subject that is in focus.

Because a close-up lens provides only a limited focusing range, it is most convenient to buy two or more of them to use either in combination or individually. The most useful powers are +3 and +2 dioptre—lower powers have too little effect when used with a standard lens, and higher powers, too much.

Although there are formulae which can be used to calculate the new point of sharp focus when a close-up lens is fitted to a prime lens, these are unnecessary when using an SLR camera, because the image can be viewed directly through the lens. Once you get used to using close-up lenses, you should not find it difficult to pick out the one that you need.

Close-up lenses have less effect on wide angle lenses, and more effect on telephotos, so if you have a range of lenses, it might be worthwhile trying out a close-up lens with several of them, as this will make a wider range of magnifications possible. This is only possible if all the lenses take the same diameter of filters, or if you have step-up or step-down rings to suit all your lenses.

The greatest advantage of using close-up supplementary lenses is that, unlike other close-up methods, no exposure compensation is necessary, and the viewfinder does not darken. This means that focusing and composing the picture is easy, and can be done in the usual way. A further advantage is that even if your camera does not have a TTL exposure meter, exposure readings from a hand-held meter will still be accurate—this is not the case with other close-up systems.

A few non-SLR cameras accept close-up lenses, but these are usually of quite low powers, and focusing must be done by guesswork or calculation. Higher powers make the camera viewfinder useless, because parallax becomes a serious problem, and with twin lens reflex cameras focusing becomes a tedious routine involving swapping the close-up lens from the viewing to the taking lens and back again. Rangefinder cameras can sometimes be fitted with a close-up lens and a special adapter, which simultaneously corrects parallax and alters the rangefinder to work at short distances.

The major drawback to close-up lenses is that the image quality they produce is not very good. This is particularly true with high power close-up lenses, but whichever one you are using, you should stop the camera lens down to the smallest practical aperture, as this will improve the performance of the combination. Use the weakest close-up lens possible, and never use two supplementary lenses if you can get away with one. If you have to use two, fit the stronger one nearer the camera.

Using extension tubes

Extension tubes are much more expensive than close-up lenses, but they are capable of much better results. They can, however, only be used with SLR cameras. They are generally sold in sets of three tubes, each with a different length.

In use, one end of the tube is fitted to the camera body with the lens fitted into the other end. With the more expensive tubes, your camera's meter remains coupled to the lens by a series of rods and levers, but the cheapest tubes do not have this facility, and the meter can only be used in the manual mode.

The focusing distance—and also how much the image appears enlarged—depends partly on how far the lens is from the film. The larger the lens exten-

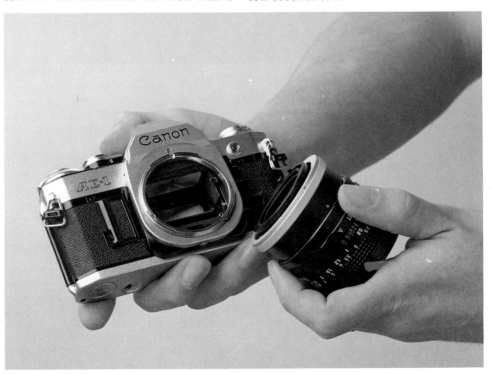

sion, the greater is the degree of enlargement, so stacking up three extension tubes behind a lens allows you to focus much closer than if you just use one. The focal length of the lens in use also has an effect. The longer its focal length, the greater extension is needed to reach a particular magnification.

If a lens is moved from the film until it is twice its focal length away, the image on the film will be exactly the same size as the subject. This means that to form a life size image, a 200 mm lens needs a four times as much extension as a 50 mm.

The exact size of each extension ring varies between manufacturers so the precise degree of magnification also varies. The ideal set of rings would enable the photographer to focus on any point from the minimum focusing distance of the lens alone, right down to life size or closer. In reality, this would need

more than three rings, and most sets either leave gaps in the focusing range, or cover a more limited range of magnifications. However, most close-up pictures can be cropped at the printing stage if the subject does not fill the frame perfectly, so this is not a really serious drawback.

Focusing with close-up lenses is partly a matter of knowing which tube to fit in order to get the subject in focus at a certain distance, though this is easy to learn with practice. Once you have fitted a tube, moving back and forth brings the subject into the plane of sharp focus. As with close-up lenses, the focusing action of the lens itself is only of limited use, though it can make quite a difference with the shorter tubes.

Focusing is hindered by the fact that at high magnifications, the light from the image is spread out over a larger area

Common or garden close-up *The beauty of macro photography is that it enables you to see ordinary objects in a new light. Photographed from a few centimetres away, even the most mundane objects become almost unrecognizable and can take on an interesting abstract quality. Look especially for subjects like these where all the important detail lies in a flat plane—depth of field is very limited at high magnifications*

than normal. This means that the focusing screen becomes dark, and the micro-prisms and rangefinder wedges may black out. Focusing must then be carried out using the matt glass part of the screen.

This darkening also affects the image on film, so when you are using extension tubes, you must allow some extra

exposure to take this into account. A TTL meter will automatically make the adjustment. When using a separate non-TTL meter, the extra exposure must be carefully worked out. The procedure for doing this is explained in the panel.

Automatic extension tubes retain all the normal functions of the camera with which they are used, but manual tubes may present some difficulties, particularly if the camera is fully automatic with no manual override. Since each type of camera has different characteristics, you should carefully read the instruction booklet before buying a set of extension tubes—particularly if they are not made by the camera manufacturer.

Movement and depth of field

Regardless of which method you use to take close-up pictures, depth of field is always a problem. As you get closer to your subject, it shrinks dramatically. At high magnifications, it is effectively zero, and the part of the subject that is sharp forms a flat plane—the *plane of sharp*

focus. This means that there is no margin for focusing error, and objects only a couple of millimetres in front of or behind the plane of sharp focus will be recorded on the film as a shapeless blur. Focusing must be done with great care and precision, and the lens should be stopped down as much as possible to maximize depth of field.

Subject and camera movement take on increased significance in close-up work, for this very reason. Not only does camera movement cause blur if it takes place while the shutter is open, but it can also throw the whole image out of focus. Moving the camera by a centimetre has little effect when a lens is focused on infinity, but it can render a close-up of a bumble bee totally out of focus. This makes a tripod essential for all but moderate close-ups.

A tripod can eliminate camera shake, but it can do nothing to stop subject movement. A slight breeze can blow a flower right out of the picture, and unless your subject is static, you should use the fastest possible shutter speed.

This in itself brings problems, because a fast shutter speed usually means using a wide aperture.

Since a small aperture is needed to give good depth of field, close-up pictures can present enormous exposure difficulties. The only simple solution is to load the camera with fast film, which allows both a high shutter speed and a small aperture. Electronic flash can help considerably, since it provides extra light and freezes motion, but the use of flash at short distances is in itself a fairly specialized technique, and a subsequent article deals with this.

Most of the problems with close-up work only crop up at high magnifications, or when a separate light meter is being used. With an ordinary SLR camera with through the lens metering, it is easy to take successful close-up pictures with the relatively simple equipment described here. All the pictures on the opposite page were taken with close-up lenses or extension tubes, and you can easily take equally effective pictures without even leaving your home.

Exposure compensation

All exposure meters which do not read through the lens are calibrated on the basis that the camera lens is focused on infinity. At closer subject distances, the lens is moved farther away from the film, and the light passing through the lens is spread over a wider area, so it is dimmer. This fall-off in illumination obeys a law called the inverse square law so doubling the lens extension cuts the brightness to only a quarter.

Whenever the film-to-lens distance is increased to take a close-up picture, you must allow extra exposure to take this into account. Since close-up lenses focus closer without moving the lens farther out from the film, they need no compensation, but all other close-up systems do.

The necessary correction is affected not only by the lens extension, but also by the focal length. To work out the correction, divide the total lens extension by the focal length, and square the result.

If you are not mathematical and use a 35 mm camera, you may find the chart below helpful. Set up your close-up picture, then place the chart in the subject position. Line up the right hand side of the panel with the right hand short side of the viewfinder frame, and you can then read off the compensation on the left hand side, either in the form of the number of *f*-stops by which the lens aperture should be opened, or an exposure factor, by which the exposure time should be multiplied.

You can also calculate the exposure compensation by measuring the total lens extension. Note, though, that this will not work with telephoto or retrofocus lenses.

Example

A 50 mm lens is fitted to a 30 mm extension tube to take a close-up picture, and the focusing mount of the lens provides some extra lens extension.

Since we cannot measure the lens-to-film distance directly, it must be worked

out indirectly. When the lens is focused on infinity, its extension from the film position is exactly the same as its focal length. The extra extension for closer subjects can be found by seeing how much the overall physical length of the lens increases over its length when focused on infinity. When focused on infinity, the lens extension must be the same as its focal length.
In this case:

Lens length for close up	= 48 mm (A)
Length at infinity	= 43 mm (B)
Subtract B from A	= 5 mm (C)
Extension at infinity	= 50 mm (D)
Extension tube length	= 30 mm (E)
Add C, D, and E = 5+50+30	= 85 mm

The total extension, then, is 85 mm.
Divide this by the focal length

$$\frac{85}{50} = 1.7$$

Square the result to get the compensation $1.7^2 = 2.89$
The estimated exposure time should be nearly tripled.

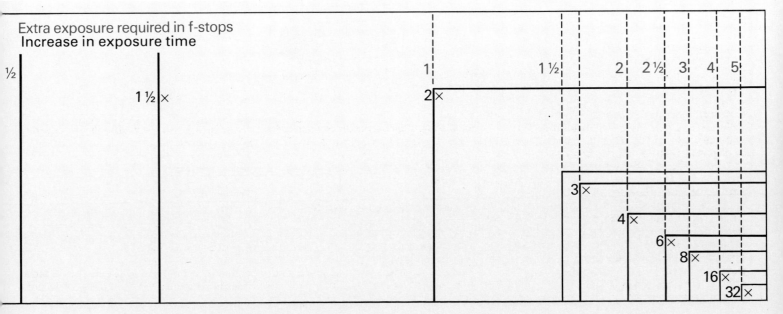

Extra exposure required in f-stops
Increase in exposure time

| ½ | 1 | 1½ | 2 | 2½ | 3 | 4 | 5 |

1½× 2× 3× 4× 6× 8× 16× 32×

Chapter 7
FILTERS
Colour balance

The most noticeable difference between the light from the sun, and the light from a 40 watt light bulb is that of quantity—the sunlight is obviously much brighter. There is, however, another difference which is of great importance to almost all photographers: light from the sun is of quite a different colour from that of the light bulb.

This difference in colour passes unnoticed most of the time, because the human eye is very accommodating. But if you see someone sitting by a window with their face lit by daylight on one side, and by a light bulb on the other, it is easy to see the difference. The daylight is much bluer than the light from indoors, which is tinged with yellow or orange.

Although our eyes can overlook minor colour shifts like this, colour film cannot. It is manufactured to very rigid specifications as to the colour of light under which it should be used. Most colour transparency film is balanced so that it will give correct results under noon daylight—that is, on a sunny day with blue sky. If photographs

Mixed light *The firelight is too yellow for daylight film and the people's faces have a yellow colour cast*

are to be taken in light which is not the same colour as daylight, then a filter must be used, either over the source of light, or over the camera lens. If this precaution is not taken, the pictures that result will have an overall colour cast—they will be tinged throughout with a particular colour. If you have ever taken colour pictures indoors by available light, you will be familiar with this problem, because the pictures will all have a yellow or orange colour cast.

In order to be able to correct for the colour cast a guidance system known as *colour temperature* has been developed (see box). Every film is balanced to reproduce colours accurately in certain lighting conditions. The colour temperature system allows the photographer to

Blue landscape *In overcast weather, pictures will be too blue in colour unless correct filtration is used*

Colour and kelvins

Candles and sunlight *This chart shows, in kelvins, the colour of the most common sources of light for photography*

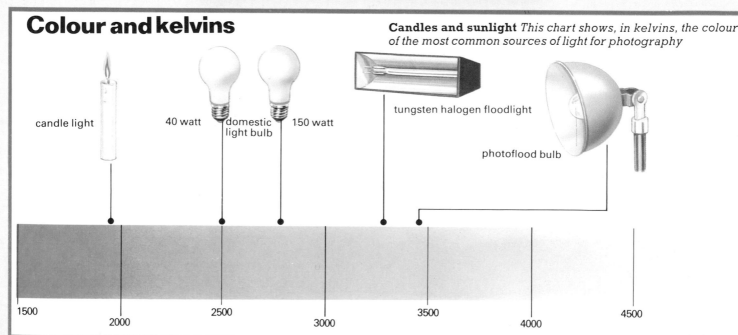

candle light 40 watt domestic light bulb 150 watt tungsten halogen floodlight photoflood bulb

1500 2000 2500 3000 3500 4000 4500

correct the colour cast produced by any lighting system.

Ordinary 'daylight type' colour transparency film is balanced for light with a colour temperature of around 6500K, and if it is to be used indoors under ordinary light bulbs, a blue filter must be used over the lens of the camera. Conversely, if the subject of the pictures is lit only by light from a blue sky—in the shade under a tree, for example—a yellow filter would have to be used.

Which filter ?

The colour temperature system seems complicated at first glance, because there are so many possible colours of light. Fortunately, though, the number of different light sources that are used for photography is small, and manufacturers produce glass and gelatine filters which compensate for most types of lighting.

To take a practical example on an overcast day, the colour of light from the sky lies between 6500K and 7500K, and unless corrected, will produce a blue cast on colour transparency film. This can be compensated for by using a series 81 filter—an 81A, 81B or 81C. The 81A is the palest of the three, and is used in slightly overcast weather, whereas the deepest, the 81C, would be used only on a very dull day. The 81B is the best compromise, and can be used for correction on most overcast days.

Light from the sun is much

Evening light *Around dawn and dusk the colour temperature drops, and sunlight looks much redder in colour*

redder in colour in the morning and evening, and here the correction that is needed lies towards the blue end of the spectrum. An 82A filter produces the correct colour balance within two hours of dawn and dusk.

Tungsten balanced film

Since it is sometimes necessary to take pictures in tungsten lighting in the studio, a few film manufacturers make a slide film that is balanced for use in this light. This is called 'type B' film, or just 'tungsten film'. Most professional lighting gives off a light which has a colour temperature of 3200K, so this is the colour temperature for which tungsten film is balanced.

If you have daylight film in your camera, and you want to take a few pictures under tungsten light, there is a deep blue filter available which can compensate for this—an 80B —but the results may not be perfect. This solution should only really be used as a stop gap measure.

Colour negative film users have fewer problems than photographers who take colour slides, because much of the colour cast which results from incorrect matching of light and film can be compensated for in printing.

Light sources and colour

Photographers use a system called 'colour temperature' to specify the colour of any particular source of light. This system is based on the idea that hot objects glow and give off a particular colour of light at a particular temperature. A hot iron bar, for example, will glow red at fairly low temperatures, and as it is heated further will change colour to orange, through yellow, to white.

By specifying the temperature at which the heated object—actually a theoretical object called a 'perfect black bodied radiator'—gives off light of a certain colour, it is possible to refer to the colour of any light source.

Since this system was devised for scientific use, colour temperature is measured in the units most commonly used in science, which are called kelvins or K. These are the same heat intervals as degrees centigrade, but start at absolute zero—minus 273 degrees centigrade. Consequently, water boils at 373K and freezes at 273K.

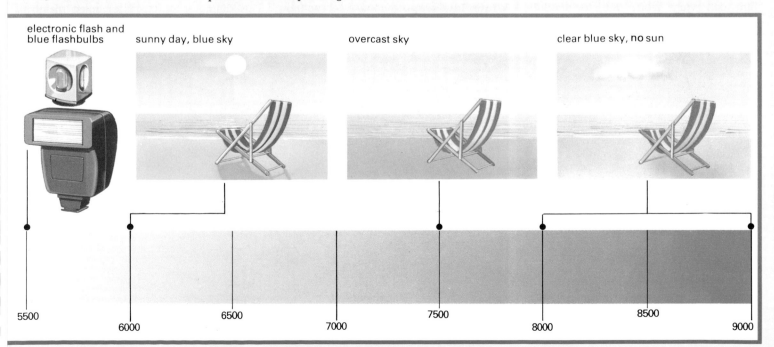

electronic flash and blue flashbulbs

sunny day, blue sky

overcast sky

clear blue sky, no sun

5500 6000 6500 7000 7500 8000 8500 9000

Special effect filters

Special effects filters are no longer the exclusive preserve of the professional photographer—they are now widely available in apparently endless variety, at a price that any amateur can afford. Because they are so cheap and easy to use, there is a great temptation to buy half a dozen of them, and use them as often as possible, but this generally results in a collection of mediocre photographs, all of which look remarkably similar to each other.

The real skill in using any special filter is to use it appropriately and sparingly. The effect a filter produces should enhance a picture, not overpower it—just as an accompanying pianist complements a singer.

Graduated filters

The most straightforward and useful type of special effects filter is the graduated filter. This is simply a piece of glass or plastic that is half clear and half coloured. The boundary between the two halves is not abrupt—the two areas blend together. Graduated filters are made in neutral grey, and in a wide range of other colours. Some manufacturers make them in two different densities—the coloured half is available as either a pale colour or a deeper one.

Although graduated filters are available in the usual circular mounts which screw on the front of the lens, you can also buy a more versatile version, which takes the form of a square of plastic and a special holder. The filter can be slid up and down in the holder, and rotated. This makes it possible to line up the boundary between the clear and coloured areas with any feature in the picture.

Graduated filters are most often used to darken the sky, or to change its colour. Because the sky is so much brighter than the rest of the picture, it is usually overexposed on colour film. A graduated filter can cure this, without cutting out light from the rest of the scene. By using a grey filter, the sky on a sunny day is recorded as a deep blue. Without a graduated filter, it often appears pale and weak. The paler of the two densities of grey produces a moderate darkening, but the dark grey graduated filter gives a very dramatic effect—rather like a tropical sky, or an early morning deep blue sky.

Coloured graduated filters can also be used with a blue sky. A blue filter can make the sky a richer shade of blue, but other colours can also be very effective. A yellow filter, for instance, can drain all colour from the sky, making it an ominous slate grey. By combining it with a polarizer, you can turn the sky almost black, without affecting the foreground of the picture.

Cartwheels *Prismatic attachments can sometimes be used for novelty value*

Twinkling city *A starburst filter greatly improved this picture of Hong Kong, without totally dominating it*

Eastern dusk *Used with subtlety, effect filters can transform a picture. Here, two graduated filters were used to darken the sky and the water*

Some photographers rotate the filter so that the darker half covers the foreground, and then take an exposure meter reading from the sky to determine the exposure. This technique gives great detail in the sky, and renders the ground as a dark, featureless shape—a useful way of dealing with distracting foreground detail if you want to take a series of cloud pictures. Generally, however, exposure meter readings are taken in the normal way when a graduated filter is in use. The filter only cuts out light from the sky, so if anything, it should improve the accuracy of a TTL meter by preventing it from being too strongly influenced by the sky.

When you are using black and white film, graduated filters can improve a picture which includes the sky. Red and orange filters are often used to give very dramatic skies, but they have a number of disadvantages—first, they absorb a lot of light, sometimes as much as three stops. Second, since they strongly absorb blue light, they tend to deepen the shadows in a sunlit scene which are illuminated by blue light from the sky. This increases the contrast, and pictures taken on a sunny day with a red filter can be very difficult to print. A graduated orange or red filter gets round both these problems, because it only acts on the sky, and does not increase the contrast of the foreground scene, or cut out any light from it.

If you use colour negative film, and do not print it yourself, a grey graduated filter allows you to get better results from a commercial enprinting or machine printing service, by effectively 'burning in' the sky at the camera stage. As with colour transparencies, this gives a deeper, richer blue to the sky.

On dull days

Photos taken on an overcast day usually have blank white expanses of sky lacking in interest. Although a blue graduated filter will not produce a convincing blue sky from an overcast one, other filter colours can be used very effectively to relieve the monotonous expanse of low cloud. This is particularly useful with wide angle lenses, which tend to take in more of the sky than longer focal lengths.

Graduated filters have uses other than darkening or colouring skies. Grey graduated filters can be useful for flash pictures. By positioning the dark portion over the foreground, the falloff of illumination with distance can be reduced, giving more even lighting. Because a graduated filter is placed close to the lens, the area of blending between the clear and coloured portion does not appear sharp in the final picture. The exact degree of unsharpness, however, depends on the focal length of the lens being used and on its aperture. Long focus lenses have very little depth of field, so if you are using a graduated filter at full aperture on a telephoto lens, the area of blending is almost imperceptible. On the other hand, an ultra-wide angle lens forms quite a sharp image of the boundary. The only way to avoid this is to use two of the weaker graduated filters, and overlap the areas of blending to give a more gradual boundary.

Whichever lens you use with a graduated filter, the working aperture has a great bearing on the effect pro-

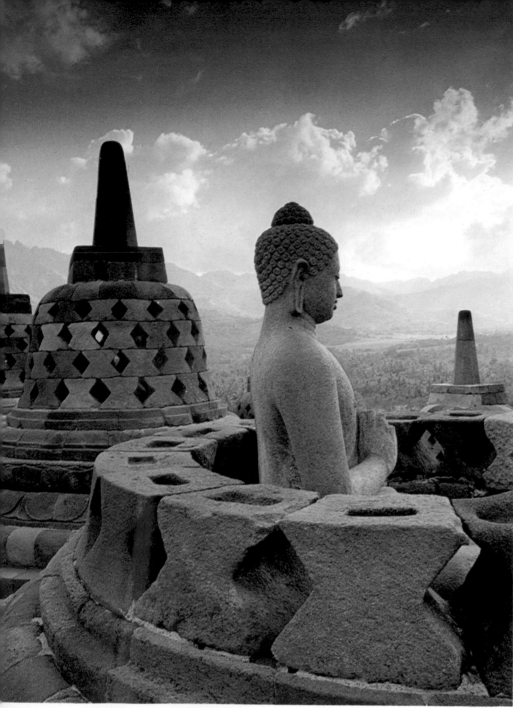

duced, and if you are using an SLR that has depth of field preview, always use this to examine the final result.

Starburst filters

Graduated filters are more useful for general daytime photography out of doors, but starburst filters come into their own in the studio, or outside at night. Starburst filters produce bright multi-pointed streaks of light from every highlight in a picture, pointing outwards away from the light source. This makes them ideal for adding an extra sparkle to the highlights in a night scene, making streetlamps and windows twinkle like stars. For a still life in the studio, a starburst filter can make jewellery, glass and metal highlights flash with light, instead of just having burnt out highlights.

These filters are made in a number of different versions, giving anything from two- to sixteen-pointed stars. By combining two or more filters, you could

Dark skies *Graduated filters are most useful for adding interest to a dull sky, either by making it warmer, or by giving it a stormy look. Take care if you are using a wide angle lens, or the boundary zone may be obvious.*

theoretically have unlimited numbers of points on each highlight. Unfortunately, this is not possible in practice, because of the way that starburst filters are made. The 'stars' are produced by minute lines on the surface of the filter. They are either scratched on to plastic sheets, or scribed with a diamond on to glass. The effect of this is similar to a scratched lens, and not only do you get starbursts, but you also get flare.

Glass filters have narrower, more precisely scribed lines, and produce only a little flare, but scratched plastic filters form a veiling fog that obscures fine detail in a picture, and fills in shadow detail. Try and use starburst filters only in pictures where a misty,

Add a sparkle *Starburst filters produce a pattern of brilliant daggers of light whereas diffraction filters give rainbow coloured circles or spots. Both work best if there are light sources or bright reflections in the picture*

romantic mood is required. They work best where there are many very bright highlights, with an overall low level of illumination over the rest of the picture. Under these conditions, the bright stars stand out clearly against the dark background.

Flat lighting produces disappointing results with a starburst filter, so you should avoid evenly lit scenes. Even coloured neon advertising signs are not sufficiently bright to produce strong, clearly defined starburst patterns, and in studio pictures you should aim to use harsh lighting to give bright, powerful highlights. Spotlights or any other small sources of light are ideal for lighting a still life with starburst highlights.

Professional studio pictures, particularly of jewellery, require very precise, sparkling highlights, and pin sharp clarity over the rest of the picture. The way to achieve this is to make a double exposure on a large format studio camera. First the still life is photographed in the normal way, but without a starburst filter in place. The photographer then marks the focusing screen of the camera with a wax pencil at the points where the starburst highlights are to appear, and replaces the still life with a sheet of black card. Tiny holes are punched in the black card in the positions corresponding to the marks on the focusing screen, and the card is lit from behind. With a starburst filter in place, a second exposure is made on the same piece of film, and the starbursts appear exactly where the photographer wants them, without creating flare in the shadows.

If you have a camera with a removable pentaprism, there is no reason why you

Unlikely colour
Effects filters can produce quite unexpected colouring in a photograph. But you must take particular care to avoid hideous combinations

Starburst ship
The rotating mount fitted to starburst filters makes it possible to position the spikes where you want them

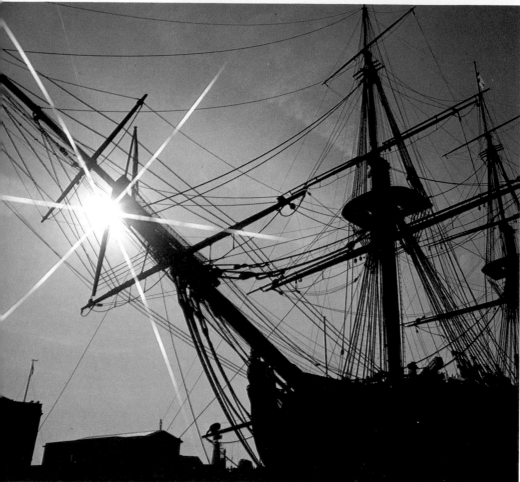

moved in the frame to the position where they look most effective. Both types of filter should be checked at the working aperture before making the exposure, because, like graduated filters, the effects they produce sometimes look different when the lens is wide open. If your camera has a depth of field preview button you can do this, but if it has not, you will have to rely on trial and error to learn what the final result looks like.

Prismatic and multi-image filters
Faced with an unpromising subject you may be able to make some sort of interesting picture by using a multi-image attachment. This is a series of angular faces, cut or moulded on to a block of glass or plastic. Each face forms a separate image of the subject, so the final picture consists of three or more identical images ranged around a fourth. The central image is usually clearer than the others, which often have coloured fringes around them owing to refraction.

When used with a subject that has bold striking detail, surrounded by a dark or neutral surround, a multi-image prism can sometimes produce a rather pleasing result. A large variety of different prism patterns are made, but however ingenious they may seem in a catalogue, it is difficult to regard them as any more than a novelty. They can be used creatively once in a while, but the effect becomes tiresome if it is used too much.

Filter overkill
There are many other types of effects filters available. Some of them might be useful in circumstances where it would be otherwise impossible to produce an interesting picture, but many of them are of limited practical use.

Special effects filters are not a substitute for creativity and imagination, but some of them, particularly graduated filters, have a real value if they are used with discretion. Even the more exotic kinds are cheap enough to buy for amusement, and can very occasionally produce an interesting picture—but use them sparingly.

should not use this technique yourself, though the larger the camera format, the easier it is to achieve.

Diffraction filters
Diffraction filters are similar in some respects to starburst filters—they give their best results in similar conditions, where there are bright light sources or reflections, and a dark surrounding area. Instead of starbursts, however, diffraction filters produce a spear of coloured light, or a jagged halo in rainbow colours, on either side of a light source. Like starburst filters, diffraction filters are scribed with lines, but in this case, the lines are minutely thin and closely packed. They are so small that

they are invisible to the naked eye. The lines cause diffraction when light from the highlights of the picture strikes them, and they split the light into its component colours, in much the same way as a prism does.

Because diffraction filters produce coloured images, they are of little use on black and white film, where a starburst filter has a more pronounced effect. On colour film, though, the effect can be used creatively to put colour into a scene that has little inherent colour of its own—such as a snow scene at night, or the concrete jungle of the inner city.

Both starburst and diffraction filters can be rotated in their mounts so that the lines of light that they produce can be

Special effects

You may think it requires sophisticated equipment to take the kind of photograph that shows a moving dancer as a series of ghosted images—or that you for the camera, a tripod minimizes the problems of proper framing and smooth operation—it is essential to keep the camera still for these special effects.

to 'fool' the shutter/winding mechanism link. You should check the camera's instruction manual to see if the manufacturer recommends any particular way of doing this.

One method is as follows: tighten the film in the camera by turning the rewind knob until firm resistance is felt. This helps to ensure that the film stays precisely in place for the second exposure. Make the first exposure. Press the rewind button and hold it in place while you wind on the film advance lever. With most cameras, this resets the camera shutter without winding on the film and you can expose the same frame again by pressing the shutter release.

You can repeat this sequence to make several exposures on the same piece of film, but the film may begin to slip out of register after a couple of exposures. Even with just two exposures you should take extreme care to ensure that the film does not move at all.

There are very few cameras with which it is impossible to make multiple exposures, although with some you may have to resort to advancing the film one frame and then winding back. You can calculate the correct exposure for multiple images very easily. The idea is normally to underexpose each part of the multiple exposure so that the total exposure of the frame is the same as for a single normal exposure. With most cameras and subjects, the best way to do

Monky business *Electronic flash lit the subject at the start of a time exposure in a darkened room. The halo is a circular fluorescent tube switched on briefly behind the subject's head, and the glowing outline was given by a hand held torch and a starburst filter*

Triple portrait *A straightforward triple exposure by electronic flash, made by moving the subject against a black background to prevent overlap when the flash fired*

have to be a darkroom wizard to produce a picture that shows the same person twice in the same shot. But these and many other special effects can be achieved very easily on the vast majority of cameras with simple exposure variations and a few very basic and inexpensive accessories.

Two principal techniques are involved in producing these special effects: exposing the same piece of film more than once, or *multiple exposure*; and long exposure times. The only essential piece of additional equipment is a tripod. Although hand-held shots are sometimes feasible and it may occasionally be possible to improvise a support

Multiple exposures

Exposing the same piece of film twice used to be a common beginner's error. Now cameras are specially designed to prevent this happening—the shutter is linked to the winding mechanism so that you cannot press the shutter again until you have wound on to the next frame. Making multiple exposures on an old camera is very simple, but on modern cameras you have to make a few adjustments to expose the same piece of film twice or more.

Some cameras have a special multiple exposure control which allows you to press the shutter any number of times before winding on. On others, you have

this is to multiply the ASA (ISO) rating of the film by the number of exposures you intend to make on a single frame, and set the new rating on the exposure meter or film speed dial. If you want to make a double exposure, double the film speed. If you want to make a triple exposure, multiply the film speed by three—effectively giving each frame a third of the normal exposure. With the new film speed set, the exposure that your meter indicates is then automatically correct.

An occasion when you should not use this method is when making multiple exposures of a brightly lit subject against a completely black background, with each new image superimposed on the dark background—spotlit figures on a dark stage, for example. In such cases, make each exposure at the normal rating for the film, preferably basing the exposure on a light reading taken from the subject itself.

If you alter the ASA setting on your meter, always remember to reset the correct rating when you have finished making multiple exposures.

Multiple subjects

Multiple exposures can be used in a variety of ways. You could, for example, make two exposures of the same subject from different points of view. Or you could use a medium or long telephoto lens to make two exposures, one in focus and the other out of focus. This can be particularly effective when photographing flowers, but you need a tripod to ensure that the framing for both exposures is identical.

Another technique is to use a zoom lens (again on a tripod) to superimpose two exposures made at different focal length settings. Experiment with such techniques to discover the possibilities.

Waterfalls and fountains are good subjects for multiple exposure shots. Rather than freeze all movement with a high shutter speed, many photographers prefer to use long exposures when taking pictures of waterfalls to show the movement of the water over the rocks. This can be effective and gives the fall a beautiful ethereal quality, but it also looks rather unreal. A multiple exposure can prove an attractive compromise between the frozen image with a high shutter speed and the unrealistic image with a slow shutter speed. Set the camera on a tripod and make a number of exposures on the same frame—up to eight—using a high shutter speed. In the final result, the water will have much of the solidity of a high shutter speed shot, with individual drops of spray visible, but the multiple images will also combine to suggest movement. Multiple exposure pictures can be made on other occasions where the main subject is stationary but where there are moving details. Those parts of the scene that move between exposures register in the final photograph in an unnatural but often fascinating way. Again, a tripod is essential to prevent camera movement.

In the late 19th century, an entire photographic sub-industry grew up to manufacture 'spirit photographs', an amusing application of multiple exposure technique that is easily performed. A suitably dressed 'ghost' is posed in an

Neon sign *A straight shot taken at night on colour slide film, with the camera set on a firm tripod*

Focus change *For half the exposure time the camera was used normally. Then the focusing ring was turned to give a blur*

appropriate scene. Two exposures are made on the same frame, one with the 'ghost' in position, one with the 'ghost' removed. The final picture shows a normal scene with a semi-transparent figure included.

A more modern variation on such trickery is multiple exposure with marking. By covering half the lens with an opaque mask, making an exposure, then moving the mask to cover the other half of the lens and making a second exposure on the same frame, it is possible to make pictures in which the same person appears twice. The model is simply moved from one half of the picture to the other between exposures.

A mask can easily be cut out of black cardboard, but it is better to use one made by a filter manufacturer since precise registration between the two images is needed. Suitable masks are made by manufacturers of square 'system' filters. The depth of field of the lens will have an influence on the sharpness of the dividing line between the two halves of the picture. Telephoto lenses should be set at a small aperture to give good separation between the two halves. With through-the-lens metering systems, always take an exposure reading before putting the mask in place, using the correct film speed setting.

There are occasions when you can use successful multiple exposure effects without a tripod. If you have a camera with a motor winder and a multiple exposure control, you can produce

Quads *Double exposure with a mask to divide the picture down the centre. To produce four images of one face, it is easiest to use a pair of identical twins as models*

Zoom *The zoom control ring on an 80-200 mm zoom lens was moved as smoothly as possible during exposure*

Tilt *After an initial steady exposure, the camera was carefully tilted up and down to give a streaked effect*

interesting multiple exposure effects with a hand-held camera. Such effects are most easily produced with those cameras that have automatic shut-offs on their motor winds, so that you can preset the number of exposures that are made. The result is a recognizable but jumbled picture of your subject.

If you have a sophisticated camera that allows you to change focusing screens, it can be useful to put a ruled grid screen in your camera when making multiple exposures. This helps you locate the separate images correctly in the frame to avoid overlap.

Flash techniques

Although the most obvious way of making a multiple exposure is to fire the shutter a number of times, you can also make a multiple exposure by holding the shutter open for a long time and illuminating the subject briefly a number of times. The simplest way of doing this is to use electronic flash and a time exposure. For each 'exposure' the flash is fired once to record the image.

This technique is usually used in a darkened room under controlled conditions, but it is also possible to use similar techniques outdoors at night. With a moving subject, multiple exposure with flash produces a series of frozen instants recorded on the film. This can be useful for analyzing motion, or purely for graphic effect. The technique is used commercially for subjects ranging from machinery to golf strokes.

Foliage *Multiple exposure in daylight can be performed successfully if you use a motor drive. The number of exposures was pre-set on the drive so that the exposure could be worked out*

With a rapidly moving subject, you need to make your 'exposures' very quickly with the minimum time between flashes. Although your ability to fire the gun quickly makes a difference, the real limiting factor is the time it takes the gun to recycle between flashes. Unfortunately, most small flash guns do not produce enough light nor do they recycle quickly enough to be used effectively with large or distant subjects—unless the movement is very slow. Nevertheless most automatic flashguns should recycle rapidly enough for small, close-up subjects. At close distances the flash emitted by such units is very brief, and thyristor circuitry enables them to recycle in less than a second. A few flashguns have manually variable power controls, and when used at their lowest setting with high speed film can allow multiple flash exposures to be made of a wider range of subjects.

This technique can be used with a variety of moving subjects, although it is probably best to try out your skill with human subjects first rather than machines. With human power, you can vary the speed of movement to suit the technique much more easily.

The procedure for this type of shot is relatively straightforward. First set up your subject in a darkened room against a black background. Before turning the lights out, frame your subject so that all the important action occurs within the picture area. Rehearse the movement you are photographing a couple of times to ensure that it all falls within the frame and looks as you want it to. Set the camera's shutter to B, for a time exposure, and the aperture to the setting appropriate to the film speed as indicated on the calculator dial of your flash.

When everything is ready, turn out the lights, open the camera's shutter, start the action, and trigger the flash unit repeatedly until sufficient exposures have been made. Close the shutter when you have made enough flashes. To give your flash tube time to cool off, wait a minute or so before exposing another frame by the same technique.

Alternatives to flash

Although electronic flash is the most obvious source of light for this type of multiple exposure, you can use others. It is possible to light some subjects with a small stroboscope, of the type intended for use in discotheques, for instance. These recycle very quickly but have a

Big wheel *Taken with a long exposure time, moving subjects like this brightly lit fairground ride make dazzling patterns. A steady tripod is essential for good results*

Light streaks *At night, city lights can make patterns like abstract paintings. Make a hand-held time exposure using tungsten balanced slide film for varied colour*

very low power output. You must experiment to find the aperture that gives correct exposure. It is likely to be fairly wide open.

Another simple and often effective technique that can produce an effect similar to multiple flash exposure in normal daylight, is to use a rotating shutter in front of the lens. This is nothing more than a circle of black card with one or more sectors cut into it, mounted in such a way—with a nail through the centre, for instance—that it can be spun rapidly in front of the lens. A time exposure is made with the shutter spinning. Every time the open sector passes in front of the lens, exposure is made, so that as the shutter spins, a number of different exposures are made. Exposure is necessarily hit-and-miss with this method, and results lack the sharpness given by electronic flash.

Long exposure effects

Most normal photographs are made with exposures of a fraction of a second, but sometimes you can use very long exposures to create a particular effect. Moving objects will blur in the final image or can be made to disappear altogether. The camera must be mounted on a tripod to hold it steady and keep static parts of the picture sharp. Because long exposures let a great deal of light on to the film, you should use a slow film and a narrow aperture. If this still results in overexposure, you may need to use a neutral density filter to cut down the amount of light reaching the lens (see page 79).

With a long exposure you can reduce a waterfall to a blur, turn traffic at night into long streaks of light, or make a busy street appear completely empty since any moving object will not be recorded at all with a sufficiently long exposure. The range of potential subjects is very wide.

Long exposures will normally only produce a special effect if the scene contains some movement, but you may be able to inject movement into a static subject by moving the camera or lens during exposure. If you move the cam-

era it should be mounted on a sturdy tripod with a pan and tilt head. City lights at night, especially neon signs, are ideal subjects for panned or tilted long exposure effects.

It is often worth making half the exposure with the camera stationary so that the pattern of the lights is recognizable. Finding the best exposure for such subjects can be difficult and you should make a number of different exposures, remembering that with colour slide films it is best to aim towards underexposure so that the colours of the lights are rich and well saturated.

Rather than moving the camera, you can produce a different but equally interesting effect by changing the setting of the lens during a long exposure. Twisting the focusing ring to throw the image completely out of focus halfway through the exposure gives a sharp image surrounded by a soft blur. A popular variation is to use a zoom lens and alter the focal length during exposure. This gives even static subjects an appearance of dynamic, exploding motion. If you use a slow film, you should be able to use sufficiently long exposures to complete the movement even in daylight—providing you move the zoom control quickly. Begin zooming at the same instant as you release the camera shutter. It does not matter if you change the focus setting slightly during zooming, since definition is not important in this type of picture.

It is possible to combine elements of multiple exposure and long exposure techniques to produce interesting results. For example, you can put a glowing outline around a subject photographed in a darkened room with no more equipment than a torch, a flash and a tripod. Arrange your subject in front of your camera, which should be mounted on as solid a tripod as possible. Set the shutter speed to B and fit a locking cable release. Plug your flash unit into the camera's PC socket, and carry out a last check to make sure that everything is ready, and that your torch is to hand.

When you release the shutter, the flash will fire, illuminating the subject. Hold the shutter open by locking the cable release, and move over to your subject—live subjects must be kept perfectly still for the next stage of the process. Switch on the torch and carefully trace around the outline of your subject in the dark, with the torch beam shining in the general direction of the camera lens. It is best if you wear dark clothing during this phase so that your image is not recorded on the film. When you have finished outlining the subject, close the camera shutter.

Zoom *Zoom effects can be created in daylight if you use slow colour film and a small aperture setting. A tripod is vital to produce fully controlled effects, without disturbing up and down or side to side vibrations*

Moonscape *Tiny set built in a studio, using high alumina cement for the Moon surface and parts from plastic model kits for the Moonbase. To give a greater illusion of luminosity, the Earth and stars were added in two exposures*

Chapter 8
THE SUBJECT
An eye for a picture

Good pictures are made in the view-finder. A photographer may produce technically superb results with quality equipment and skilful processing, but unless the original image is right, he can rarely create a good picture. Not every-one is born with that elusive 'eye for a picture'—but with practice and common sense, most people can avoid common mistakes and improve their results.

Of course, there are no hard and fast rules that can be applied to guarantee brilliant creative photographs every time. Identifying a potential picture in the field and exploiting it to full effect is a matter of artistic judgement and cannot easily be taught. Nevertheless, there are a few guidelines that may give you an idea what to look for, and what to avoid.

While stunning results may sometimes be achieved by deliberately ignoring these rules, they should help you to learn from your successes and failures and develop your own photographic eye.

Using the viewfinder

Perhaps the most valuable lesson the photographer learns from experience is to think before pressing the shutter; shooting first and asking questions later will almost inevitably waste film without guaranteeing a good shot. While there are some situations in which a moment's hesitation is a moment lost, it is often worth spending a few seconds studying the scene in the viewfinder.

Try to imagine the scene as it will appear as a print or slide rather than an image in the viewfinder. And ask your-self just what it is you want to photograph and what effect you want to achieve.

A panorama, for instance, requires an entirely different approach to a close-up of a local church or an informal portrait. In a portrait of a child, for example, the child should be the centre of attention in the final result. This does not mean that the child must be right in the centre of the picture—such symmetrical images are often dull and lifeless—but that the viewer's eyes should be drawn to the child and not distracted by numerous other points of interest within the frame. Backgrounds should generally be kept simple and uncluttered.

This is where a good gaze through the viewfinder is so valuable. A camera is 'a mirror with a memory' and it will faith-fully record every detail of the image it receives through the lens. The human brain is not so faithful to the eye and it is surprising how little of the scene you actually take in. You tend to concentrate on things that interest you rather than take in the whole scene. Because you are so absorbed with the child in the fore-ground, it is easy to miss an unsightly garden shed or the car parked behind, either of which may detract from the finished picture. Forgetting this can often lead to unintentionally amusing results.

Framing *When taking landscapes and town scenes, it is often worth using a dark foreground like this archway to 'frame' the subject.*

easily achieved with a telephoto lens than with a standard one, which is one of the reasons why a lens with a focal length of about 90 mm is chosen for portraits by many photographers in preference to the standard 50 mm.

As well as not competing with the subject, the background can also be made to complement and highlight it. A dark subject generally looks better against a light background and vice versa. A filter over the lens can help to emphasize any difference. When using black-and-white film, an orange or red filter will darken a blue sky almost to blackness and so show up a light-toned building or figure. Such filters can also make a sky more dramatic by making white clouds stand out against the dark sky.

In a similar manner, a visually complex subject will look far more impressive against a simple background such as the sky while the impact of a very simple object is often enhanced by a dense background. But complexity in the background depends on more than simply the number of individual details. In colour shots, a profusion of various colours can be just as awkward to deal with. When photographing a friend in a garden, for instance, it is usually better

Viewfinder *A camera records only part of any scene and the photographer must use his viewfinder thoughtfully and decide what to include and what to reject*

Photographs of cars that appear to have sprouted lampposts, or dogs with flowers growing from their heads, have been taken by even the most experienced photographers from time to time.

Dealing with distractions

If you do spot potential distractions in the background, try moving around until they are outside the frame and you are left with a simpler, stronger picture. Alternatively, adopt a very high or a very low viewpoint so that the background is mainly sky or ground. If the background seems to intrude from every angle, move in close until your subject dominates the picture in the viewfinder.

Moving in close has a number of advantages it makes the photograph simpler and helps to fill the frame out with the central image, giving it more weight. But be careful when you are closing in; you may lose the background altogether and get a rather abstract result. Or you may find that objects nearer the lens are unnaturally large. People sitting facing the camera can acquire giant feet or huge bulbous noses simply because of the apparently dis-

torted perspective at close range.

One technique that experienced photographers use to simplify the background is to set the camera on a wide aperture to restrict the depth of field. This enables them to focus selectively on the object of interest and keep the background blurred and indistinct. This effect is more

Format *Many pictures are taken with the camera horizontal, but a vertical format can lift an otherwise dull photo out of the ordinary. Compare the picture below with that on the right. Notice how the extra foreground gives the vertical picture depth and how a narrow frame and the children pointing eagerly emphasize the show as the focal point of the picture. The horizontal picture has little depth and many distractions*

to move the subject closer to the flower bed and use a background of one colour flowers rather than set him or her well away against a riot of many coloured flowers, however pretty they may look.

Creating depth

While the original scene is in three dimensions, the final photograph is only in two. If the picture is not to appear dull and flat, there must be an illusion of depth. Your subject should appear to stand out from its background and be obviously some distance in front of it. Composition is an important part of this process of creating the illusion of depth, but so too are colour and tone.

Certain colours and tones have significantly different visual depths. Light tones come forward while blacks tend to recede, and a strong picture is more easily achieved by photographing a light subject against a dark background than vice versa. However, careful use of lighting—such as strong backlighting on the subject—can lift even a dark subject out of the picture.

Similarly, warm, bright colours such as red and orange appear to move out from the picture while colder colours such as blue and green tend to recede. Blue sky therefore makes a good background to most subjects. It is simple, and except when the sky is completely empty of clouds, is sufficiently interesting not to be lifeless. Being blue it helps to push the subject forwards.

In landscapes, you can use the foreground to create the illusion of depth. Dark and light areas have a different

Depth *Foreground hills appear much darker than those far away. By including dark foreground objects you can create an impression of depth*

effect in these pictures. In real life, the distant hills in a panorama appear much lighter and in more muted colours than the nearby trees. To put depth in your photographs, this effect can be recreated. Try to enliven a panorama by placing a strong, dark object in the foreground. This should be a simple shape, though, so that it complements the detail of the distant view. Silhouetted trees, for instance, frequently uplift a misty distance view.

But where in the picture do you locate all these elements? This is a question of balance and composition. Although people have tried to formulate rules in the past, none have been particularly

successful. Yet while balanced composition remains largely a matter of personal judgement, there are a few basic points to watch for.

If, for instance, the horizon is placed half-way up the frame, the sky and ground are two equal areas competing for attention. Sometimes this can be dramatic, but usually the result is unsatisfying. If you want to take a picture of the sky, let the sky occupy more of the frame; if you are interested in the ground, let the ground take more space.

Complete symmetry is rarely pleasing. You can usually get a better picture by approaching subjects from an angle rather than flat on. Pictures of people

Balance *Variations in the relationship between the important elements of a picture have a tremendous influence on its final impact. In this picture, the glowing gold of the wheat completely overshadows the house and trees behind. Were the wheatfield to occupy only a small area of the frame, the rest of the picture would still seem dull by comparison. So the photographer has made the wheat his subject and allowed it to fill two thirds of the frame so the sombre colours of the house and trees provide a nice contrast that heightens the colour of the corn*

staring straight into the camera tend to look dull and lifeless. A country lane scene usually looks better from one side of the road rather than looking straight down the middle. But of course, because oblique views are generally preferred, head-on views are unusual and may be visually arresting.

Lines in the picture

Look for lines and shapes within the picture and try to work out what they do to the overall effect. Strong parallel horizontal or vertical lines tend to break up a picture but like head-on views can occasionally be used to great effect.

Pictures where the eye is led towards the centre of the picture are generally more pleasing than those that appear to have no central point of visual interest. Lines converging towards the centre or top of the frame complement perspective and draw the eye into the picture. Diverging lines prevent the eye moving easily towards the centre and generally make the photograph much less satisfying. Similarly, highlights are best kept fairly near the centre; otherwise the eye tends to wander out of the frame. In fact a dark area 'framing' the scene—such as a silhouetted archway or branch—can complete the picture and hold the viewer's attention.

Balance

Although again there are no infallible principles, a well-balanced picture can often be achieved by using the 'inter-

Distractions *Water seems to be gushing from the woman's head because the photographer failed to notice the fountain*

section of thirds' idea. If you imagine a picture divided into three, horizontally and vertically, then placing a subject at any of the intersections of the horizontal and vertical lines contributes to a balanced result. This seems to work because the extra visual weight of the subject is balanced by the larger but visually lighter remainder of the frame. Alternatively two points of interest could be located at diagonally opposite intersections.

Different colours and different tones (in black and white) have different visual weights. Even small highlights and splashes of bright colours (such as red) have a great deal of impact and should not really be near the edge of the picture —unless you want to achieve some special effect. If they have to be near the perimeter, try to balance them out with large areas of lighter tone or another point of interest.

When using colour, a whole new range of possibilities open up. Beware of shoot-

ing colour for colour's sake, however. While a mass of bright colours in a carnival may appear an ideal shot for colour work, you will probably get better results by having just one or two small areas of bright colour. Place a parrot and a colourful bouquet in the same picture and both will compete for attention. But a few splashes of bright red among the pastel greens and browns of a misty woodland can make a picture sparkle.

Whatever advice you are given, however, photography is ultimately a matter of personal experience and judgement. Though exotic locations lend themselves to exotic pictures, beautiful or interesting photographs can be found anywhere. To improve your eye, look around your home or go out into your local neighbourhood and try to look at everything with a fresh eye, exploring even the most mundane objects for photographic possibilities. You may be surprised how much material you can find.

Simplicity and style *Although these photographs cover a wide range of subjects, they have one thing in common: they are all beautifully simple. In each case, the photographer makes it abundantly clear what he is shooting and allows no extraneous detail into the frame to distract attention away from his subject.* **Old man** *The plain black background and dark jacket bring out the rich colour and texture of the skin. With the man looking straight into the camera, it is a wonderfully direct and honest picture, but it avoids the usual harshness of such head-on views by including the dove cupped in his hands at the centre of the frame to balance the face. The result is a gentle and touching portrait.* **Child opening the door** *shows the value of thoughtful composition to create an enchanting photograph. By keeping the child small in relation to the frame and placing him in the bottom corner, the photographer has mimicked the way the child is dwarfed by the door. But because the rest of the picture is so simple, it does not distract attention from the tiny figure. Notice how the curve of the little boy's body as he twists the door handle contrasts with the straight lines of the door frame and wall.* **Landscape** *is unusual in having no obvious focus of attention, but it works by virtue of the strong pattern of fields and lane.* **Snowscape** *shows how effective a single red highlight can be and the* **nude** *forms a beautifully compact but intricate shape*

Portraits

Taking someone's portrait is, perhaps, the most personal of all photographic assignments, and portraits are probably the most treasured of all photographs. Millions of wallets, walls, desks and mantlepieces the world over are adorned with pictures of faces which are loved and cherished.

But the magic of creating a photo that instantly captures the look and personality of a friend or relative has very little to do with cameras and equipment. Successful portraiture—recording and preserving the likeness of someone—depends as much on the photographer seeing and shooting at the right time and in the right place.

The best advice for any photographer wanting to succeed in revealing a flattering yet recognizable likeness of a friend or relative on film is to think about your subject before the session.

Bronzed *Strong sunlight brings out the rich gold of the suntanned skin but the face is kept in shadow to avoid harsh and unflattering modelling*

Looking in *The child's face glows against the dark window surround and warmly wrapped coat and peeps appealingly into the corner of the frame*

What are the pleasing or outstanding characteristics about him or her, and how could you successfully translate them onto film?

The best place to start taking portraits is outdoors. The light is far brighter than indoors, offering a wide choice of possibilities ranging from the strong harsh sunlight on the beach to the deep shadow of the woodland floor on a rainy day. The number of potential settings is also enormous—gardens, shopping arcades, mountains, fields and so on. And taking portraits outdoors can often be spontaneous. You might decide to take a friend's portrait on the spur of the moment, while walking across the park, for instance.

Spontaneity can be vital because in a formal situation people tend to become self-conscious and expressions become forced. Most people are terribly anxious

and shy about having their photograph taken, and may be apprehensive about the finished result.

Until your subject is relaxed, it can be difficult to get a good portrait. The art is to make the session an enjoyable event for both subject and photographer. If it all feels like a chore, that is how the results will look. Be prepared to use a lot of film on the session, letting the subject get used to the camera and waiting for the right expression.

Talk to your subject. Tell jokes. If you want a relaxed atmosphere, you have to be at ease yourself. Confidence and a friendly manner are an essential part of achieving good portraits. You will probably need practice before you can relax and take control because, unlike your subject, you will be doing two things at once—talking and trying to take the shot.

Portraiture essentially involves two people, the photographer and subject, and it is normally expected that the

Old man *A man portrayed against a background of the work that occupies over half his life. The rough texture of the skin encouraged a close up*

photographer should take the initiative. Unless your subject is a professional model or actor, it is not enough to simply place him or her in front of the camera and press the shutter. You have to direct your subject in the nicest and friendliest possible way.

Overdirecting, however, can be worse than not directing at all. If you force your subject into a pose, he will resent it and feel like a helpless puppet and ill-at-ease. It will also almost certainly produce a 'stuffed portrait'. On the other hand, it is not enough to just say 'smile' and hope for the best.

The happy medium, wherever possible, is to make your subject feel that he or she is a valuable part of the creative process. Get him to take a positive part in the session and suggest new poses. These may be more natural to him. He may feel awkward standing up, for instance, and lean against a wall or sit down to make himself comfortable. Unless you have positive reasons for the upright pose, you should encourage changes of position.

Many people become very self-conscious about their hands when sitting for a portrait and you should always suggest to your subject what to do with them. You might, for instance, want a casual impression and might suggest that his hands go in his pockets. Or you could give him something to hold.

But remember that hands can contribute to the composition. Hands are a very important means of expression and may draw attention to some feature of character that would be missed, or hard

Man and his dog *Animals can say a lot about personality. The mutual respect and affection clear in this picture suggest a gentle but strong willed man*

99

your subject you will need to consider the setting. Ideally, the background should relate in some way to your subject. What should be avoided are backgrounds which dominate by being too strong or intricate.

The best all-round illumination for photographing people is evenly diffused light—soft, flattering shadows can be produced with the filtered, hazy light of a misty morning or in a shaded setting, such as in a wood or under a tree. Bright cloudy days are particularly good. In addition, subjects often feel more comfortable in this sort of lighting than they do in direct sunlight, which can make them squint.

However, soft light may sometimes hide the very character lines you wish to bring out. Unless you want to hide their wrinkles, weather-beaten faces need strong direct light to bring out the rich skin texture.

The point to remember is that you are responsible for whatever is in the frame of your camera. Look at it carefully, and especially train yourself to be aware of distractions, such as a lamp post coming out of your subject's head or a strand of hair that has cast an ugly shadow.

Although good portraits can be taken on virtually any equipment, there is something to be said for choosing a lens to suit the type of shot you have in mind. For head-and-shoulders shots, an 85-120 mm zoom, or a fixed focal length telephoto within the same range, are probably best because you have to stand farther back than you would with the standard lens. This reduces the chances of distortion of features close to the camera—close-ups with a standard lens can often produce huge noses or overprominent chins. Another advan-

Johnny Morris *Hands can be a problem in portraits, but they were kept nicely occupied for this picture to provide a relaxed and informal portrait*

to show, in a simply facial portrait. A thoughtful person, for instance, might rest his chin on his hand. An ebullient person may place his hands definitely on his knees when sitting or on his waist when standing. Cupped or open hands can sometimes suggest vulnerability. However the hands are used, though, they should look part of your subject's natural repertoire of hand movements.

Thinking about your subject and looking for his or her best attributes will help you to decide how to take the photo. If he or she has attractive eyes, for instance, close in on the face. The wrinkled faces of some older people may be so fascinating that a close-up of the face alone provides a strong and interesting image.

Many photographers are unsure how to approach close-ups. Should the subject look at the camera obliquely or stare straight into the camera? Or should he not look at the camera at all?

Most people nowadays tend to prefer an oblique shot, often with the head slightly tilted, because this seems more natural and unforced. A head-on approach, on the other hand, although it often seems horribly formal, can produce striking portraits of forceful characters. Whatever approach you choose, however, it should be appropriate to the person you are trying to portray.

Your aim might be to take a photo that particularly flatters your subject, however, in which case you want to find the angle that obscures the less attractive or weaker parts of the face. A broad face, particularly a broad chin, can be made to look narrower by shooting from a high angle and getting the subject to tilt his or her chin away from the camera. A weak chin, on the other hand, can be made to look stronger by shooting slightly upwards from a low angle.

As well as thinking carefully about

Artur Rubinstein *This charming portrait of a famous musician shows that a successful picture does not need an obvious musical background*

Unusual viewpoint *Changing the angle of your shots can produce dramatic changes in mood. These can be particularly effective in black and white; this shot might well look weak in colour*

Cricketer *One of the best ways to portray people is to catch them at their favourite activity or in their working environment. Here a cricketer's bat is a useful prop and a sign of his trade*

tage with long lenses for close-up work is that you subdue sharp, overdistinct features flatteringly. Remember, though, that this could work against you if the subject has very shallow features. One final point in favour of a short telephoto is that the comparatively narrow depth of field allows you to keep the background blurred more easily.

With half- or full-length shots, however, it is probably better to retain your standard lens. You may even wish to use a wide angle lens for these shots for special effects. A short person can look very tall if photographed from a low angle with a wide angle lens. And even with close-ups you may be able to use a short focal length lens to create a dynamic and moody impression, but with this sort of shot you must choose your viewpoint carefully or the result could be bizarre.

But whatever equipment you use, the success of your portraits depends ultimately upon your relationship with your subject and the confidence that comes from experience and a keen interest in the people that you portray.

Happy couple *Shots like this depend less on careful posing than establishing a rapport with your subject. It is virtually impossible to fake laughter*

101

landscapes

When your holiday photographs are developed, do you ever wonder what happened to those glorious, sweeping views, those majestic, rolling landscapes? Did they really look so insignificant? Somehow, your memory and the picture do not agree.

Amateur landscape photographs are often disappointing. It is not the choice of subject that is usually at fault, but the conditions under which the subject was photographed. Professionals can wait for hours for a particular light, perhaps returning to the same spot day after day until they feel the conditions are perfect for the right picture. The amateur cannot usually afford such luxury and having found an attractive view snaps and moves on. But with careful forethought and an understanding of those elements which can really help to make your picture distinctive, you can avoid more disappointing photographs.

Light and weather are the landscape photographer's two most valuable and creative tools. A landscape can change dramatically when illuminated from different directions and it is well worth observing exactly how the look of the land alters as the sun moves in the sky.

Early morning and late evening are the times favoured most by landscape photographers. Shadows are softer then than in the middle of the day, and the warmer tones help to accentuate the form and texture of the land. Early morning light is particularly attractive when accompanied by a hazy, translucent mist. Think of a field full of sheep on a cold winter's morning. Nothing very remarkable to photograph, but the same scene photographed in a thick dawn mist could be an entirely different prospect. The sheep become ghostly figures, hardly discernible in the gloom, creating a haunting, more memorable image. Remember that you do not have to record factually every detail you see —your picture may have more impact if you hint at what is there instead.

The weather obviously has an influence on the quality of light. Bright, sunny days will cast more shadows, whatever time of day it is, while grey overcast days may tend to make your pictures rather flat and lacking in depth.

As a general rule, exaggerated weather conditions will probably produce the most dramatic shots. Some of the best landscape pictures have been taken in atrocious weather and even the most disappointing views can look considerably more exciting in a storm or in frosty weather. Use adverse conditions to show up the real bones of the country.

Learning to manipulate the light to improve your picture takes a good deal of experience. One of the most spectacular ways of using light in landscape is to shoot into the light itself. This may present some exposure problems, but by bracketing the exposure you should produce one image at least that approaches the effect you want. Look, too, for interesting shapes that would look effective in silhouette form and choose a vantage point that sets the subject against the light in the most original way.

Aerial view *This shot of a tractor tilling an American field makes very effective use of rural patterns. Its success lies in careful composition*

Stone boathouse *This lovely lakeside scene benefits from having a building included. It adds a point of interest and features some local stonework*

If you would like to do more landscape photography, but can never actually get started, it might be a good idea to set yourself a project. One idea is to choose a river and spend a day tracing its course, using it as a base from which to explore all the photographic possibilities as you go along. You might find a map useful, the kind that shows contours clearly, so you can work out where the best vantage points are likely to be. It is even worth considering spending a few days simply exploring a particular area to find the most suitable and attractive locations, spending time searching for the best viewpoint and thinking about the mood you wish to create.

The mood will largely depend on the kind of landscape you are going to photograph. It could be the traditional panoramic 'vista' type scene, the picture postcard variety, which embraces a wide area and can instantly give the viewer an impression of its beauty. Or it could be a smaller rural scene, depicting a part of farm life. You may prefer to close in on a subject, perhaps a group of animals grazing or an unusual pattern within the landscape.

It may be the beauty of the area you wish to capture, or the feel and style of an area, perhaps its characteristic boundary walls or unique farm buildings.

Composition in landscape is almost as important as lighting and weather. Knowing when things 'look right' is largely a question of experience, but a good way to develop your sense of composition is to study good landscape paintings, and see exactly why they work. The crucial balance is a complex combination of the right relationship between a number of elements like light and shade, different colours and proportion of foreground to sky. Try looking at a photograph that you instinctively feel does not look right and see if you can pinpoint the elements that seem to throw the picture off balance. Perhaps it is a tree that detracts too much from the main subject, diverting the eye

and causing confusion. If you can identify the particular aspect that is working against the balance, you are on the way to creating well composed photographs of your own.

One of the advantages of landscape photography is that its more static nature gives you more time to spend composing each shot carefully and choosing what appears within the frame. Before you press the shutter, train yourself to glance around the edges of the frame to make sure unwanted telephone lines or electricity pylons have not crept in and spoiled your picture.

One of the first decisions you will need to make regarding composition, particularly in the panorama type photograph, is where to put the horizon. The traditional choice is to have the sky take up two thirds of the picture, but this is by no means the rule. If the sky is particularly dramatic, a low horizon might enhance the picture. Similarly a low horizon will

accentuate the dominance of a sky in a particularly flat region. A very high horizon, on the other hand, might be more appropriate if you wish to show the patterns of the land. As always, the only way to know what is best is to experiment with the viewfinder. Move it around, stand on a wall, crouch down low and see what is most suitable.

If the sky is rather bland, a polarizing filter will darken the sky tones without affecting the other colours. If shooting in black and white, a yellow, orange or red filter will increase the impact of a weak sky, darkening it to contrast dramatically with white clouds.

Bare tree *A landscape does not have to include a wide view. It is equally effective to concentrate on a narrower area if it gives a feel of the region*

Terraced fields *The landscape varies widely throughout the world. If you travel abroad you should try to add a sense of place to your landscape*

just wandering around haphazardly, hoping for a few pictures.

Sometimes you may become engrossed in the composition and overall view of a subject that it is easy to gloss over the other interesting elements in the viewfinder. Seek out rich textures and interesting patterns that small portions of the whole scene can provide. Move in close to the textural surfaces of the soil, stone or rock formations as well as plant life itself. Look for patterns in light and shade, furrowed field, walls, the contours of land, colour relationships and the shapes of trees.

As far as equipment is concerned, there are no rules for the landscape photographer—most professionals working in this field have their own individual style and approach. You will almost certainly find that a tripod is useful, particularly in low light when you want to retain relatively small apertures and wide depth of field.

You can take an excellent range of photographs with a standard 50 mm lens, and if you have one, a medium telephoto around 105 or 135 mm to help you bring subjects closer and fill the frame. Longer focal length lenses tend to compress the distances between separate planes at distant viewpoints and you sacrifice depth, but of course you are able to magnify the subject. Some landscape photographers consistently work with lenses of around 300 mm, ideal for intricate patterns and rich textures.

When it comes to selecting film, you may decide that colour is the obvious choice. Certainly most professionals do work with colour transparencies but do not dismiss black and white too easily, as some really striking results can be achieved. When light is low, or if you want to achieve a particularly grainy effect, use a fast film.

All you can do now is start walking! The beauty is there—it is up to you to make the most of it.

Timber barns *A building does not have to be kept in the background. Sometimes it helps to compose a landscape so that buildings dominate the scene*

Grazing sheep *By combining these New Zealand mountains with a field of sheep this landscape has plenty of interest. The sky and the light also help the shot*

Another way to enhance your picture is to change your viewpoint and include a building somewhere in the picture. The eye will be drawn to it, as a point of interest, yet will take in the beauty of the scene too. It could be a single cottage, a hay barn, even a small cowshed, but its strategic placing within the overall composition can dramatically alter one's appreciation of the scene.

If your chosen theme is farmland, it should be easy to anticipate promising shots by learning about the farming calendar and talking to the farmer himself. Make it your business to find out when the lambing season begins, for instance, or when sheep shearing is to take place. Perhaps interesting new machinery is being delivered or installed. Get to know when ploughing, ditching, furrowing or planting takes place, work out your best vantage point and equipment needs before the event and make the most of the session. You will save a good deal of time and wasted effort and feel far more professional than

INDEX

Numbers in italics refer to illustrations